IMAGES
of America

THE 1964–1965 NEW YORK WORLD'S FAIR

CREATION AND LEGACY

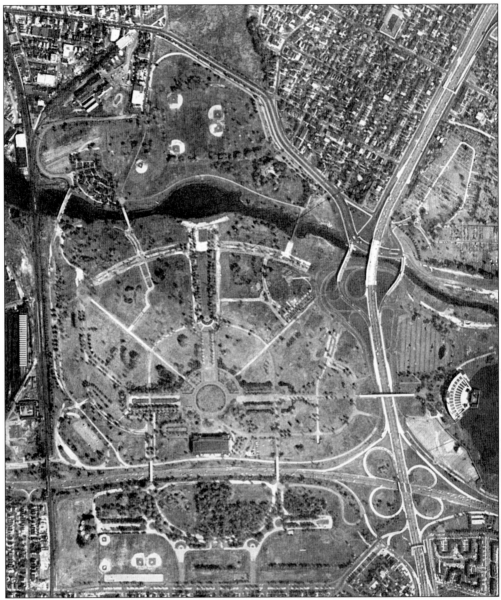

It took five years of design and construction and $1 billion to turn Flushing Meadows Park, the site of the 1939–1940 New York World's Fair, seen here in this 1960 aerial view, into a new world's fair.

On the cover: As visitors stroll past, a tyrannosaurus rex and a triceratops prepare to engage in battle. This was just one of the many sights awaiting visitors at the 1964–1965 New York World's Fair. It took over five years and $1 billion before these dinosaurs and the other exhibits could grace the little-used site that eventually hosted more than 51 million visitors from around the world. (Author's collection.)

IMAGES
of America

THE 1964–1965
NEW YORK WORLD'S FAIR
CREATION AND LEGACY

Bill Cotter and Bill Young

ARCADIA
PUBLISHING

Published by Arcadia Publishing
Charleston SC, Chicago IL, Portsmouth NH, San Francisco CA

Printed in the United States of America

Library of Congress Catalog Card Number: 2007937953

For all general information contact Arcadia Publishing at:
Telephone 843-853-2070
Fax 843-853-0044
E-mail sales@arcadiapublishing.com
For customer service and orders:
Toll-Free 1-888-313-2665

Visit us on the Internet at www.arcadiapublishing.com

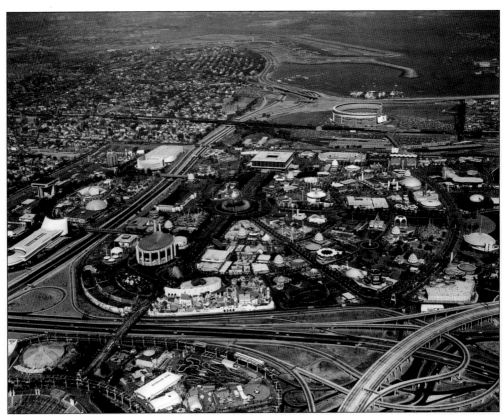

The formerly desolate and little-used Flushing Meadows Park had been transformed into a place that was quite different from anywhere else in the world when the 1964–1965 New York World's Fair opened on April 21, 1964.

CONTENTS

ACKNOWLEDGMENTS

While much of the material in this book came from our own collections, we also had the invaluable assistance of other fair fans and collectors, who supplied us with additional photographs, documents, and memories, all of which helped us paint a more complete picture of the fair. In particular, we would like to thank John Pender, who shared a wealth of information collected by him and his father, Michael Pender, deputy director of state exhibits for the fair; Karl Baker, who provided rare photographs of the construction of the fair shot by his father, Joseph Seebacher; and Gary Holmes, for pictures of memorabilia from his collection of world's fair legacies.

Our thanks also go to Mary Ellen Coughlin, John McSweeney, Randy Treadway, Kevin Carsh, Dick Horn, the Railroad Museum of Long Island, Albert Fisher, and Larry Romer for their photographic contributions and suggestions.

INTRODUCTION

In 1964, I had the pleasure of visiting the 1964–1965 New York World's Fair, an event that was to make a lasting impression on me. During the two seasons of the fair, I was lucky enough to return many times, and despite all of the hours I spent there, I always found something new to entertain me. The fair was big, dynamic, and most of all, it was fun!

Forty years later, I was thrilled to coauthor our first book about the fair. The fair had been described as an event "too big for one year," and as it turned out, it was also too big for one book. While we did our best to describe the pavilions and shows, we did not have enough space to fully explore the story behind how the fair came to be, what it took to design and build it, and what legacies it has left behind. Happily we have the opportunity to explore these subjects in this sequel, and in doing so, we are able to share some of the things we have learned about the fair over the years.

One might think that the fair was so recent and so well covered by the press of the day that all information about it would be easily available; that turned out not to be true for several reasons. Many of the pavilions were designed and built by organizations that no longer exist, and in other cases, corporate mergers and downsizing resulted in the loss of records. Luckily enough, information does exist, especially through photographs and personal collections, to turn back the clock and rediscover the story behind the fair. Hopefully these details will show what a gargantuan labor the fair was and why so many people remember it so well today.

Working on this book has been fun, for it allowed me to learn even more about the fair and to see some of the pieces of it that have been scattered across the country. Some of this research has been surprising—I learned, for example, that part of the Protestant and Orthodox Pavilion is now in a church just four miles from my house, and I have been passing by it for over 20 years without ever knowing a part of the fair was so close.

My visits to the fair would not have been possible without the support of my parents, for I was only 12 when it opened. They encouraged my interest in the design of the fair and tolerated my desire to bring new treasures home to save after each visit. In later years, especially since the availability of the Internet and eBay, my wife, Carol, has also agreed to share our home with an ever-increasing number of boxes filled with information, photographs, and other collectibles. I offer my thanks to them for their understanding and support and to Carol for proofreading my work and for her invaluable suggestions.

I have been fortunate to have visited several world's fairs, and though they are all big, dynamic, and fun, none of them have yet surpassed the thrills of those days in Flushing Meadows. Those were special days in a special place.

—Bill Cotter, November 2007
www.worldsfairphotos.com

The pictures preserved on countless photographs, showing space-age pavilions, splashing fountains, manicured gardens, balloon-toting children, and Belgian waffle–eating adults, tell a story of the 1964–1965 New York World's Fair that everyone remembers. However, there is a beginning and an end to that story that is as remarkable as the story of the fair itself but seldom given much thought or consideration.

This book, on the creation and legacies of the fair, continues the story of the fair that we began with our first book. It gives readers a glimpse into the incredible work that was required to bring the fair from concept to reality and touches upon how the fair, Flushing Meadows-Corona Park, and the creator of both, Robert Moses, are so intricately entwined. It is difficult to condense five years of design and construction, two years of operation, and two more years of park restoration into a 128-page book. We hope that the 200 photographs and sketches we have drawn from history will tell a tale of the fair that has not been told before.

—Bill Young, November 2007
www.nywf64.com

One

WHY A FAIR?

From tiny acorns mighty oaks may grow.

Like all massive projects, what became the 1964–1965 New York World's Fair began with a simple idea. In the winter of 1959, a group of New York businessmen led by Thomas J. Deegan began looking for a way to celebrate the 300th anniversary of the founding of New York, which would be in 1964.

The road from idea to reality was a bumpy one, as the exploratory committee soon found out. New York was not alone in wanting to host a world's fair. Seattle was already busy planning its fair for 1962. There was talk of a fair in the Los Angeles area, and both Chicago and Washington, D.C., were actively touting the benefits of their cities as well. In some cases, the efforts had only progressed to the talking stage. In others, architects were already working on theme and pavilion designs. How then did New York, a relative latecomer to the process, manage to beat the competition and win the rights to host a world's fair?

Perhaps, not surprisingly, the answer is politics. The planning groups each realized that they needed to have the backing of the federal government to succeed, and intense lobbying was soon underway to win approval for their fairs. Detailed studies were presented showing each city's ability to finance a fair, how each would house the prospective visitors, the interest level of corporate sponsors, air travel capability, and more. While all of this information was undoubtedly considered, New York probably won, in large part, because it represented the best of capitalism and corporate success. Foreign visitors would surely explore Manhattan and return home impressed by the skyscrapers, chic shops, famous restaurants, Broadway, and everything else New York is so famous for. Surely this message would not be lost on those contemplating the alternative to the communist system. Thus when on October 29, 1959, Pres. Dwight D. Eisenhower announced that the federal choice for the fair was New York, Deegan and his team were elated to have won the competition to entertain the world.

Convincing the government they could pull it off was one thing; convincing investors to fund it and exhibitors to participate was quite another. Before they could begin, the planners knew they needed to find someone who could get the fair designed, built, and opened on time.

World's Fair Planned Here In '64 at Half Billion Cost

Flushing Meadow Likely to Be the Site —'Biggest' Exposition to Celebrate New York's 300th Anniversary

By IRA HENRY FREEMAN

A New York world's fair, bigger than any exposition previously held anywhere, is projected for 1964.

It is likely that the fair will be built at Flushing Meadow Park, where New York's last world's fair was held in 1939 and 1940. The sponsors feel they will have to raise $500,-000,000, more than three times the cost of the 1939-40 show.

Mayor Wagner announced yesterday that he had approved preliminary plans for the fair presented to him by an organizing committee of twenty-five —made up mostly of business leaders in the city.

The committee will be enlarged at a meeting Aug. 18 to about fifty, including representatives of large corporations who may wish to become exhibitors.

Thomas J. Deegan Jr., a public relations man who has had experience in three world's fairs since 1939, is chairman of the committee.

Application for permission to hold a world's fair in New York five years from now has already been filed with the Bureau Internationale des Expositions. Abraham K. Kaufman, general counsel to the committee, recently returned from Paris, where he discussed the project with officers of the international agency.

The planning committee said that the date had been selected to "commemorate the 300th anniversary of the founding of the city." Actually, 1964 is the 300th anniversary of the name "New York."

The theme of the fair will be "Peace Through Understanding," Mr. Deegan said. How this will be expressed, what will be exhibited and who will exhibit,

Continued on Page 19, Column 3

Although the *New York Times* was confident the city would win the rights to the fair, as described in this story from August 10, 1959, the planners still needed the backing of the federal government to make their dream a reality, and they needed a dynamic personality to head up the New York World's Fair 1964–1965 Corporation that would build and operate the fair.

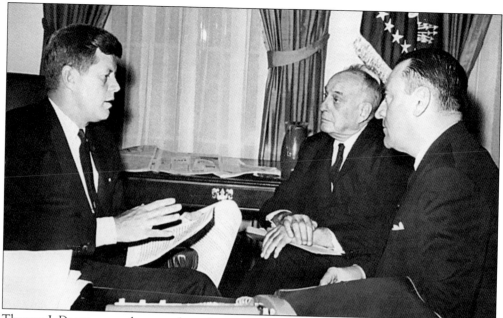

Thomas J. Deegan, seen here on the right in a meeting with Pres. John F. Kennedy and Robert Moses, spearheaded the efforts to bring a second world's fair to New York. Deegan and the other early fair planners selected Moses to be the president of the New York World's Fair 1964–1965 Corporation, knowing that he had the ability to accomplish the mammoth task ahead—to create a world's fair in five very short years.

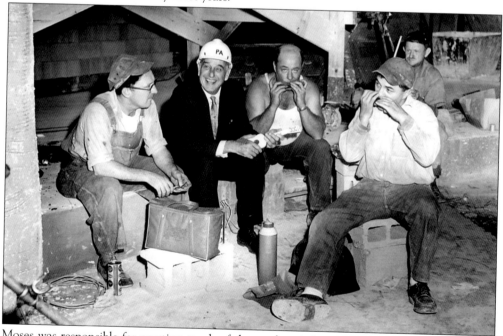

Moses was responsible for creating much of the modern infrastructure of the city, and he was experienced in successfully managing massive public works projects. His impressive credentials were essential to persuade financial institutions to lend the fair the money needed for construction and operation. He is seen here in 1963 with workers who are building the fair's heliport.

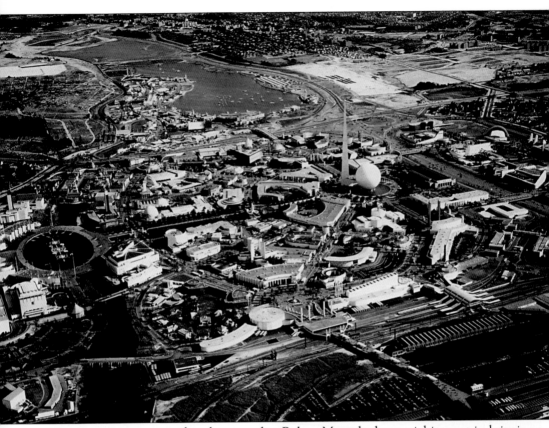

The fair's organizers were keenly aware that Robert Moses had a special interest in bringing a second world's fair to Flushing Meadows Park. The bankruptcy of the 1939–1940 world's fair had left the grand park he had planned for that fair unfinished. It was believed that a second world's fair could be Moses's vehicle to complete the park at last. For Moses, it would be his most important legacy from a lifetime of public works.

Two

DESIGNING THE FAIR

Pretty soon you'll see the dirt fly.

—Robert Moses, the *New York Times*, August 4, 1961

Following years of political wrangling to host the fair, work was needed to bring the exposition to fruition. A fair on the scale envisioned by the New York team required a massive design effort that tasked the limits of architectural and construction leaders from around the world. There were also political pitfalls to avoid, as well as the need to acquire funding for construction and operation.

One thing was certain from its inception: the fair would be held at Flushing Meadows Park. Flushing Meadows was once a refuse dump in the borough of Queens. In 1936, this blighted area was chosen by then parks commissioner Robert Moses to host the city's 1939 world's fair. The choice of Flushing Meadows for the second fair meant that millions of dollars in design and construction costs were saved by utilizing the infrastructure left behind by the first fair. Improvements to the site included construction of new arterial highways around the perimeter to improve traffic flow to the fair and the diversion of the Flushing River, which flowed through the park, to cavernous underground tunnels that provided more usable land above. The fair itself spent as little money as possible on the construction of temporary buildings. Above all, the fair was designed to maximize a return on investment; its profits would be used to complete the task begun back in 1936 of creating this greatest of urban parks.

In the early 1960s, the slide rule, pencil, and drafting board were the tools of the designers. Employing the use of such new concepts as "space frame" design, where trusses of steel bars in geometric shapes carry the stress load of the structure, as opposed to traditional designs, where steel girders and columns bear the load, they experimented with new materials like fiberglass to create pavilions of fanciful design that were modern yet functional. And although they were creating structures under a special building code that allowed for less stringent rules of construction than usual, they still had to design pavilions that remained attractive, sturdy, and safe for two full years and a harsh East Coast winter.

When the financially troubled 1939–1940 New York World's Fair closed its doors, there was barely enough money available to demolish the fair's symbols, the Trylon and Perisphere, which had stood at the center of this view. The roads and utility systems left behind formed the basic design layout for the new fair.

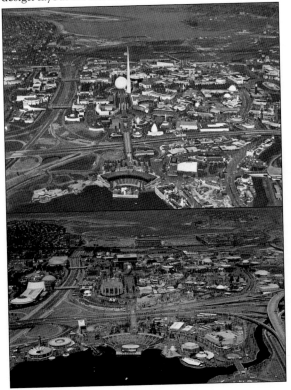

Two aerial views of the different fairs, both taken from above Meadow Lake, show how similar their layouts were. The Amphitheater and the New York City Building were retained from the first fair. Interestingly, the Florida exhibit at both fairs was located in the same spot and even used some of the original support pilings.

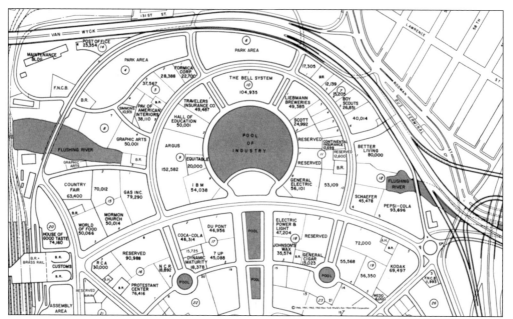

With much of the layout dictated by the roads and utilities left from the earlier fair, designers set out to allocate space for prospective exhibitors. Pavilions were to occupy a maximum of 60 percent of the plot, with the remainder of the site appropriately landscaped. Maps were updated as pavilions came and went, and many exhibits never got beyond this stage. This 1963 map has a number of pavilions that were never constructed.

Each of the structures at the fair began with concept art. In some cases, rough drawings were used in hopes of attracting funding before moving on to more polished works that could help establish the size and proportions of the building elements. Here early artwork shows one of the concepts for the Oklahoma Pavilion. The curved arch over the three-dimensional relief map was dropped from the final version.

15

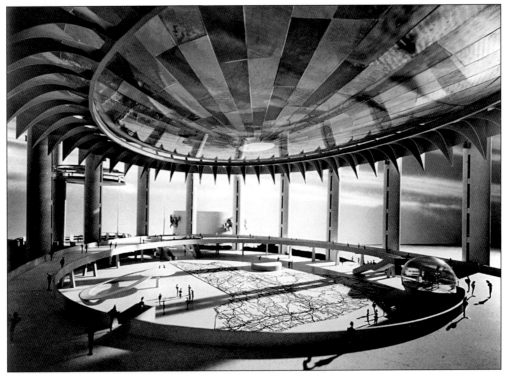

After the artwork was approved for a pavilion, the next step was to prepare a scale model such as this section of the New York State Pavilion. These very detailed models allowed designers to visualize the structure from various angles and garner interest from potential investors and the public.

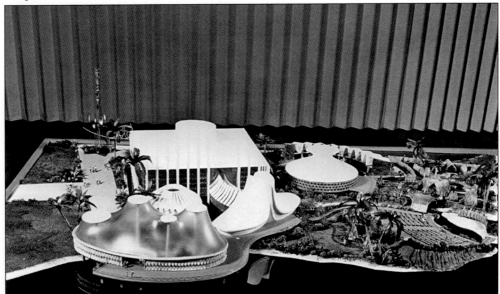

Many of the models were quite elaborate, like this one of the Hawaii Pavilion. Miniature trees and people helped illustrate the scale of the structures, and when viewed in close-up photographs, they could easily be mistaken for the real thing.

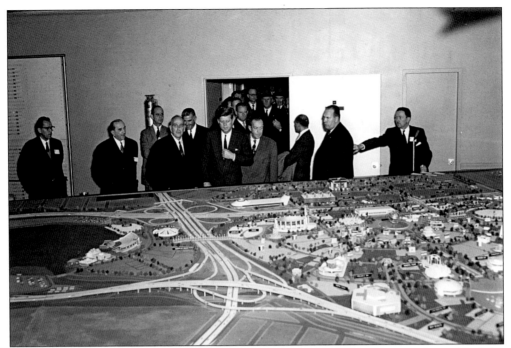

Smaller and less-elaborate models of each pavilion were placed on a giant scale model of the entire fair that was located at the New York World's Fair 1964–1965 Corporation headquarters. The model room was a popular stop for visiting dignitaries such as Pres. John F. Kennedy, seen here on December 14, 1962.

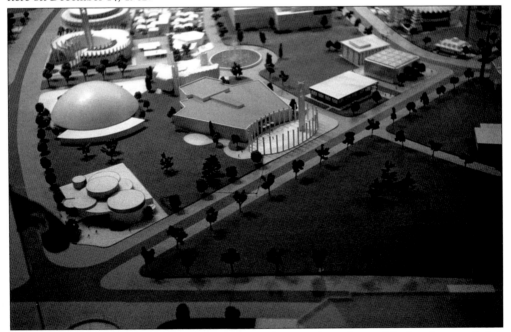

The official scale model was updated on an ongoing basis as plans changed during the negotiation and design phases of the fair. At the end of the fair, the model was destroyed, but a number of the miniature pavilions survive in private collections.

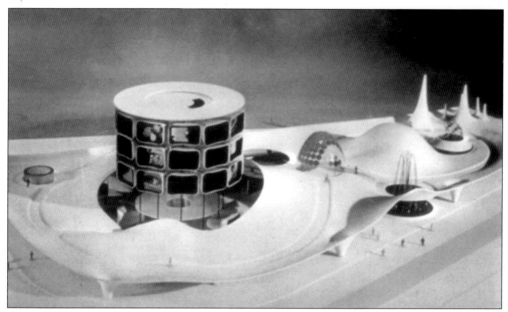

As could be expected, many pavilions changed form during the design phase. This early model of the Kodak Pavilion featured the familiar, undulating moon roof, but the pictures on the tower resembled carousel slide trays instead of the large photographs that were eventually used.

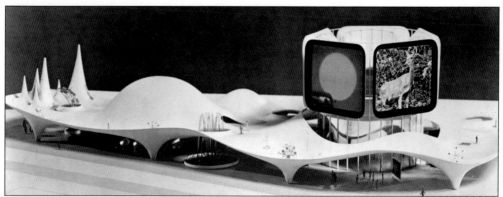

This model of the Kodak Pavilion, created later in the design process, features most of the original exhibit concepts, but the tower has been changed to a more elegant and streamlined design. Copies of this later model were sent to select Kodak dealers and photography shows to promote public interest in the upcoming world's fair.

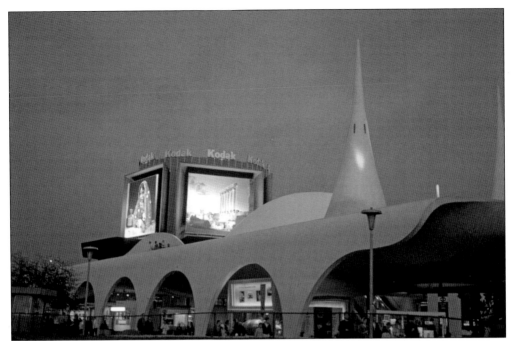

This night view shows the large pictures used in the final version. Although most visitors thought these images were giant slides, they were actually large prints lit from the front by special lighting designed for the fair.

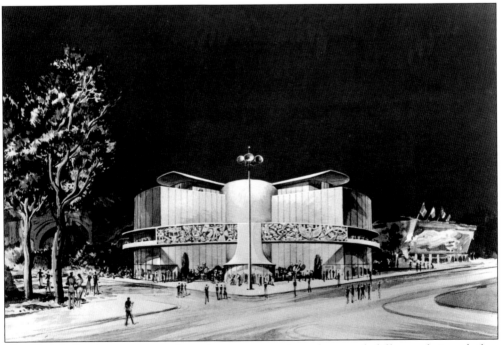

The Kodak Pavilion was not the only one to go through several different designs before construction began. This preliminary design for the DuPont Pavilion bears little resemblance to the final product and might have been more at home at the 1939–1940 fair.

Another rejected design for the DuPont Pavilion looks quite different from the other angular structure. The design has elements of the circular structure that eventually was built, but the pavilion is missing some of the space-age touches that were seen at the fair.

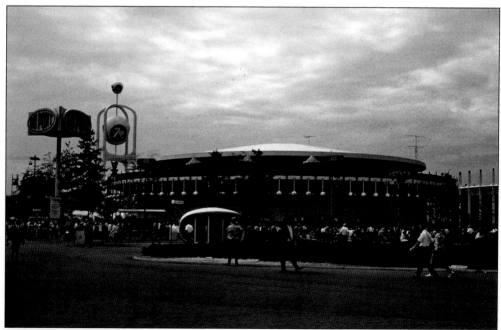

The actual DuPont Pavilion featured much cleaner lines than what was proposed in the concept artwork and was only a single-story structure. The large DuPont sign tower of the artist's rendering was greatly reduced in size, making for a more subdued presence that did not detract from the colorful building itself.

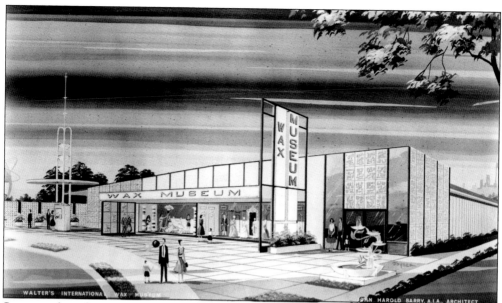

Some pavilions looked far better on paper than they did when they were finished, as it is easier to create things in the mind than in concrete and steel. In some cases, plans had to change due to the realities of construction. In many other cases, it was due to the realities of financing.

While the concept art for Walter's International Wax Museum showed a modern-looking building with clean, striking lines and signage, the completed version was a scruffy structure that was better suited to a warehouse than a fair.

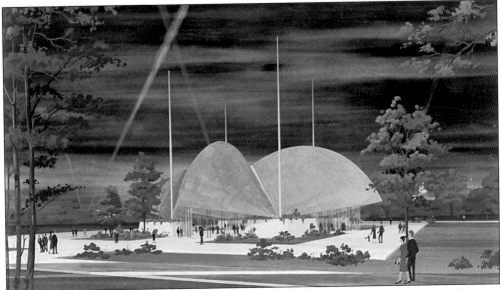

The Wisconsin Pavilion is an example of how much a pavilion design could change between concept and actual construction. This early version featured several soaring arches over a large exhibit space. Some claim they were supposed to represent wedges of cheese.

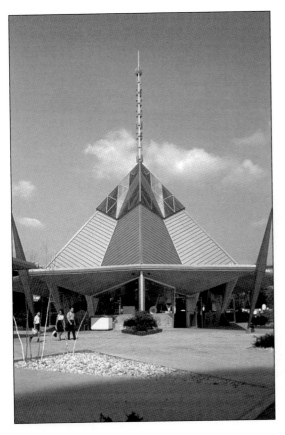

The Wisconsin Pavilion as actually constructed featured a more modest rotunda building with a sharply angled roof that was surrounded on three sides by low-level buildings containing additional exhibit space and a restaurant.

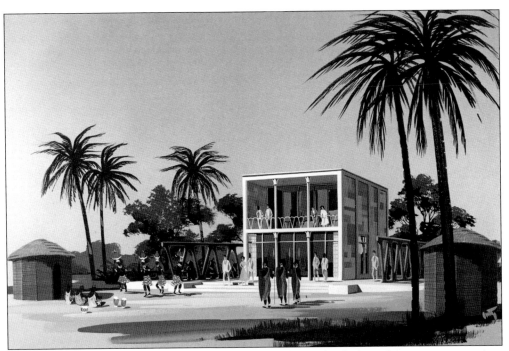

The Africa Pavilion was another project that changed completely from design to construction. This early sketch featured a very modern-looking exhibit hall that was basically just a large, square box surrounded by huts and palm trees.

The completed pavilion was quite different. It featured buildings styled after tents clustered around a circular theater. Some of the smaller buildings were raised on stilts to resemble tree houses, and there was an open-air dance area in the middle of the complex.

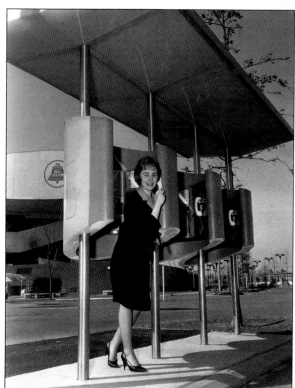

Designers tried to provide a modern and futuristic look wherever possible to make the fair a truly special place. This was not just for the main pavilions but also for such ordinary things as telephone booths. The boxy versions with folding doors in use across the country were replaced by this serpentine design in all public areas of the fair.

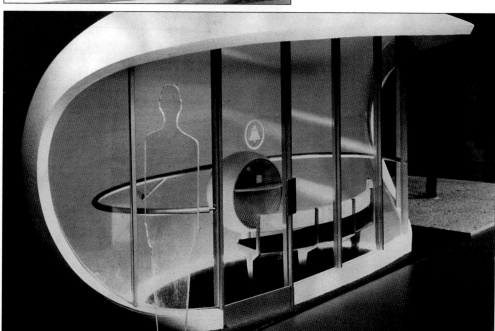

The fair also featured another very unusual type of telephone booth. This ovoid structure, dubbed the Family Phone Booth, contained a speakerphone (high tech for 1964) that allowed everyone inside to call home to let friends know about the great fair. Neither form of futuristic telephone booth ever saw use again after the fair.

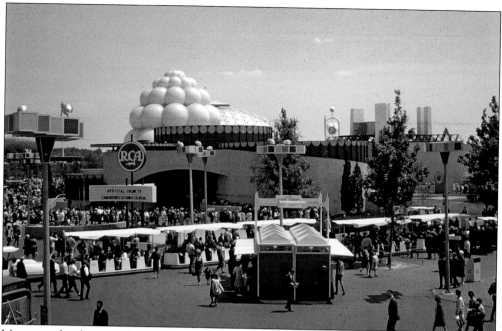

Many people who visited the fair still recall the luminaries, the futuristic streetlights that came in a seemingly never-ending variety of colors and shapes. Constructed of aluminum-framed plastic cubes that could be arranged in different patterns, a number of the luminaries included speakers that played background music and broadcast public announcements.

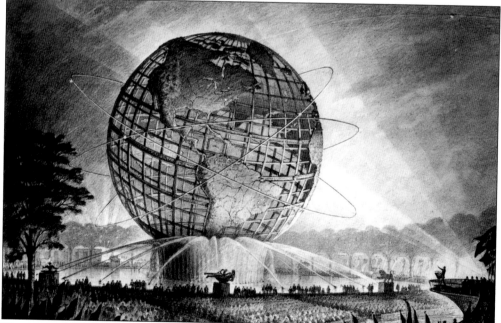

The original concept for a theme center called for the Unisphere to rotate on its base, but that scheme was deemed impractical. By the time the fair's symbol was announced, water jets obscured the base so that the Unisphere appeared to float above its reflecting pool. Lights whirled about the orbital rings, suggesting orbiting satellites.

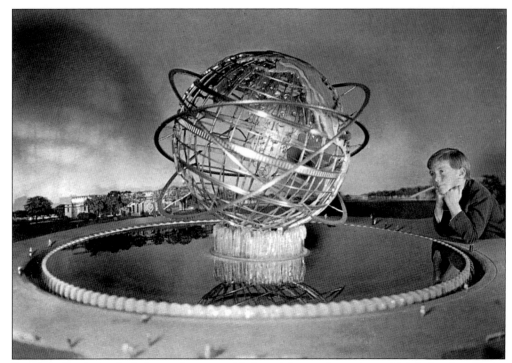

By 1960, the design had changed to one with less-elaborate fountains, which helped make the Unisphere itself more prominent. Engineers had not yet worked out all of the design calculations, and this version featured thicker elements than were required in the real structure.

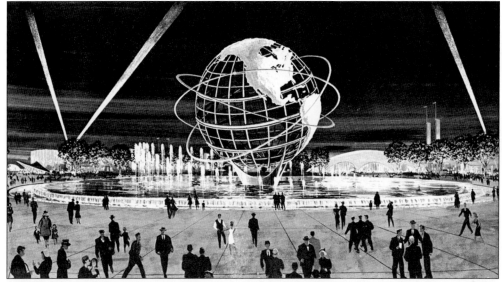

By 1961, the Unisphere design had been modified to one much closer to the armillary sphere that was eventually constructed. A tripod base supports the structure in a large, circular pool, and fountains placed away from the base rise and fall in a circular pattern, suggesting movement. Special lighting effects also suggest movement by simulating the advance of sunlight or moonlight across the continents.

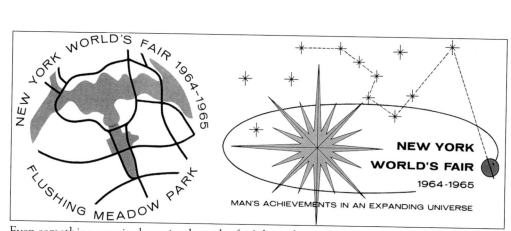

Even something seemingly as simple as the fair's logo changed over the years. The early logo on the left showed that the fair would be at Flushing Meadows, but it was created before the overall theme had been decided. Later, but prior to the Unisphere being selected as the theme center, the fair utilized an orbiting earth and Big Dipper logo to represent "Man's Achievements in an Expanding Universe," one of the often-repeated themes of the fair.

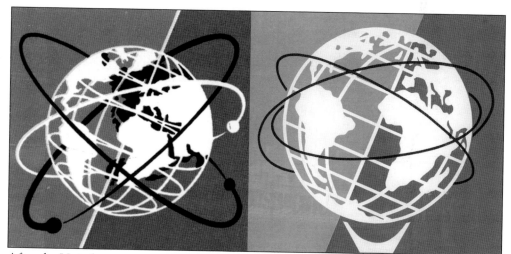

After the Unisphere was announced as the theme center, the logo used between 1961 and late 1962 reflected the design of the symbol as originally conceived; the Unisphere appears without a base, and actual model satellites orbit it. The final logo depicted a stylized Unisphere as it appeared at the fair, complete with a tripod base and simpler orbital rings.

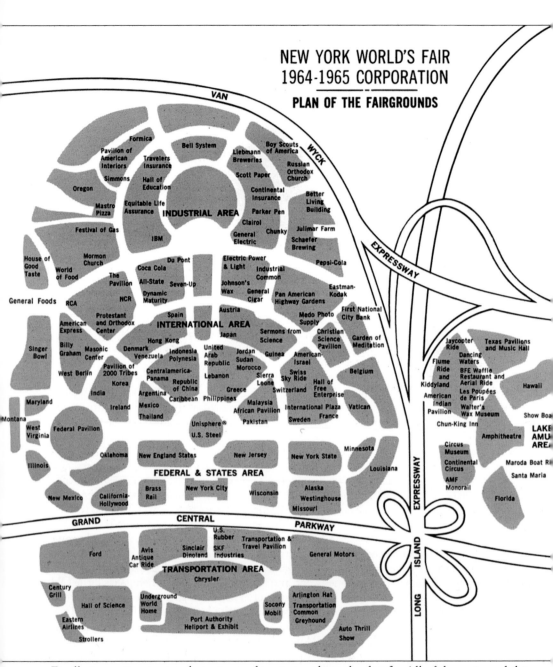

VAN

WYCK

EXPRESSWAY

Formica
Pavilion of American Interiors
Bell System
Boy Scouts of America
Liebmann Breweries
Travelers Insurance
Russian Orthodox Church
Scott Paper
Simmons
Hall of Education
Oregon
Continental Insurance
Better Living Building
Mastro Pizza
Equitable Life Assurance
INDUSTRIAL AREA
Parker Pen
Clairol
Chunky
Julimar Farm
Festival of Gas
IBM
General Electric
Schaefer Brewing
House of Good Taste
Mormon Church
Du Pont
Coca Cola
Electric Power & Light
Pepsi-Cola
World of Food
The Pavilion
All-State
Seven-Up
Industrial Common
Johnson's Wax
Eastman-Kodak
General Foods
RCA
NCR
Dynamic Maturity
General Cigar
Pan American Highway Gardens
First National City Bank
Protestant and Orthodox Center
Spain
Austria
Medo Photo Supply
American Express
INTERNATIONAL AREA
Japan
Sermons from Science
Christian Science Pavilion
Garden of Meditation
Singer Bowl
Billy Graham
Masonic Center
Hong Kong
Denmark
Indonesia
United Arab Republic
Jordan
Sudan
Guinea
American-Israel
Venezuela
Polynesia
Morocco
Swiss Sky Ride
Belgium
West Berlin
Pavilion of 2000 Tribes
Centralamerica-Panama
Korea
Republic of China
Lebanon
Sierra Leone
Switzerland
Hall of Free Enterprise
India
Argentina
Greece
Philippines
Maryland
Ireland
Mexico
Caribbean
Malaysia
African Pavilion
International Plaza
Vatican
Montana
Thailand
Unisphere®
Pakistan
Sweden
France
West Virginia
Federal Pavilion
U.S. Steel
Minnesota
Illinois
Oklahoma
New England States
New Jersey
New York State
Louisiana
FEDERAL & STATES AREA
New Mexico
California-Hollywood
Brass Rail
New York City
Wisconsin
Alaska
Westinghouse
Missouri

GRAND CENTRAL PARKWAY

Ford
Avis Antique Car Ride
Sinclair Dinoland
SKF
U.S. Rubber
Transportation & Travel Pavilion
General Motors
TRANSPORTATION AREA
Industries
Chrysler
Century Grill
Hall of Science
Underground World Home
Arlington Hat
Socony Mobil
Transportation Common
Greyhound
Eastern Airlines
Port Authority Heliport & Exhibit
Auto Thrill Show
Strollers

EXPRESSWAY

LONG ISLAND

Jaycopter Ride
Texas Pavilions and Music Hall
Flume Ride
Dancing Waters
BFE Waffle
Kiddyland
Restaurant and Aerial Ride
American Indian Pavilion
Les Poupées de Paris
Hawaii
Chun-King Inn
Walter's Wax Museum
Show Boat
Circus Museum
Amphitheatre
LAKE AMU... AREA
Continental Circus
Maroda Boat Ri...
AMF Monorail
Santa Maria
Florida

Finally it was time to stop designing and to start making the dirt fly. All of the major exhibitors are shown on this 1964 map of the fairgrounds.

Three

BUILDING THE FAIR

*An army of . . . building and construction tradesmen are racing against time
to assure that the Fair . . . will open on [time]. They play the final part
in the long task of creating reality from an idea.*

—New York World's Fair *Progress Report No. 9*, September 26, 1963

Turning all of the designs and the empty land of Flushing Meadows into the world's fair was not an easy task. Mountains of dirt had to be moved and thousands of support pilings sunk into the marshy soil. New construction techniques were needed as were workers with a wide variety of skills. The following list shows just a few of the details required to get the fair ready: 14 miles of water mains for the utility system, 130 miles of high-voltage electrical cables, 22 miles of storm and sanitary piping, and 10 gas mains. Exhibitors and concessionaires put $550 million into construction and exhibits, and in July 1963, 6,665 men worked at the fair site and 2,332 worked on related arterial highway improvements. About 250,000 tons of steel went into the construction of various exhibit buildings. Before Formica could build its "House on the Hill," it had to build the hill, and it used dirt excavated for other buildings that were constructed on the flat fairgrounds. By Labor Day in 1963, man-hours worked on the fair totaled 12,936,660, with a payroll of $65 million. Fair pavilions were constructed to withstand an Atlantic seaboard winter and hurricanes, so exhibitors saved little in construction costs. The World's Fair Marina was made by the dredging of some two million cubic yards of silt from Flushing Bay, and two years of planning plus specially made cobblestones went into the construction of Rheingold's Little Old New York. By the end of the summer of 1963, an additional 15,000 workers were thought needed in order to finish the fair on time, but work was hastened in the last quarter of the year, and the additional manpower was not needed. The Gas Companies Pavilion was the first to start building, and the groundbreaking was in April 1962, 24 months before opening day. The largest pavilions constructed for the fair were General Motors' and Ford's, with 320,000 and 227,360 square feet of floor area respectively. More than 3,500 bench units were placed in street malls and park areas throughout the fairgrounds as construction neared an end, and most pavilion foundations and roofs had an estimated "natural life" of five years.

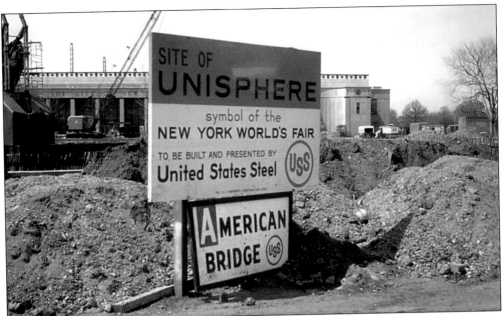

One of the most important construction jobs at the fair was the Unisphere. While other pavilions could have opened late or had construction flaws corrected after opening, it was imperative that the fair's symbol be ready for opening day. Work had just begun when this picture was taken, with excavation for the foundations taking place at the former site of the Perisphere from the 1939 fair. (Courtesy of John Pender.)

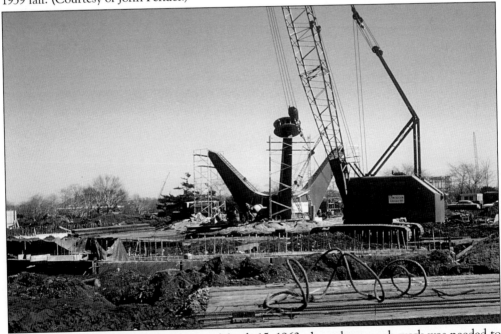

This picture of the Unisphere, taken on March 15, 1963, shows how much work was needed to ready the fair for opening just 13 short months later. At this point, the base of the Unisphere was almost complete, and soon the familiar open grid of latitudes, longitudes, and continents would rise above Flushing Meadows. (Courtesy of John Pender.)

With the base complete, cranes were brought in to begin placing the prebuilt sections of latitude and longitude lines into place. Building the 940,000-pound structure was a massive job that required many new techniques, yet the Unisphere was completed on time and without any major problems. (Courtesy of John Pender.)

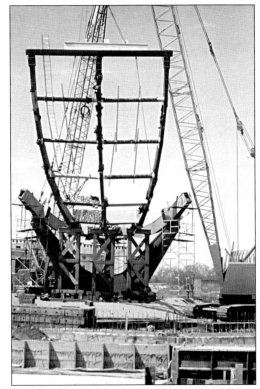

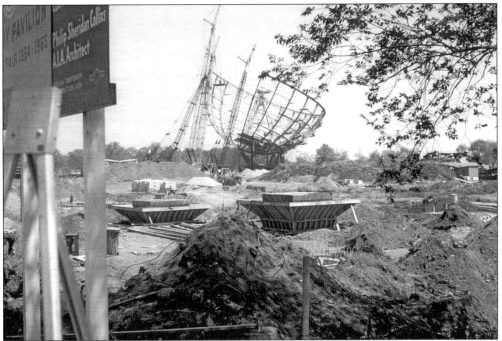

By May 27, 1963, work was approaching the equator. This view was taken from the future site of the New Jersey Pavilion. Once the northern hemisphere was added, it would be time to add the continents and surrounding fountains. (Courtesy of John Pender.)

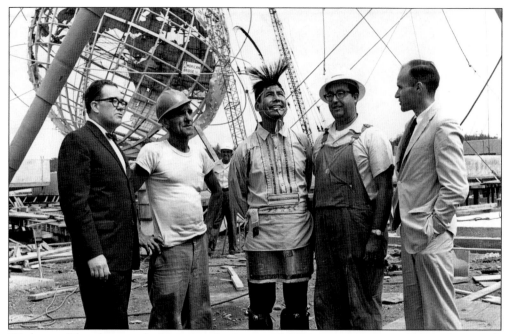

Work was all but done on the Unisphere by August 18, 1963, as seen in this publicity photograph taken at the New Jersey Pavilion site. Mike Pender, deputy director of state exhibits, is seen on the left as workers admire the steel framework. A fatality occurred during the construction of the fair when support beams for the New Jersey Pavilion collapsed, killing one workman and injuring two.

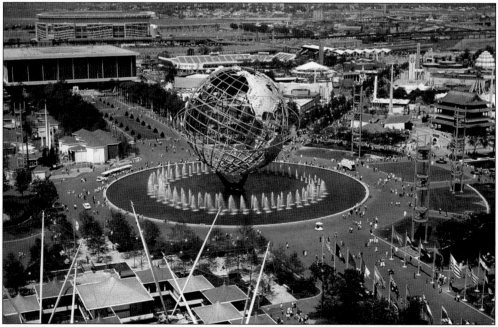

The Unisphere is one of the more recognizable symbols of any world's fair. Seen here in its glory during the fair with the Fountain of the Continents in full operation, the Unisphere is today the unofficial symbol of the borough of Queens and has been granted landmark status.

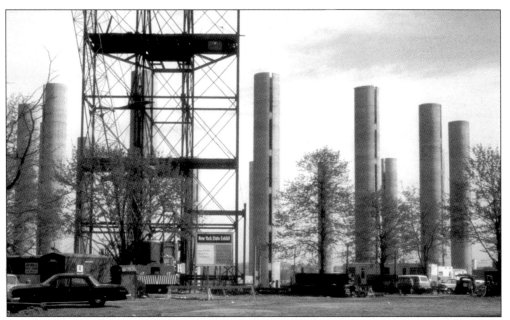

Creating the colorful roof of the Tent of Tomorrow at the New York State Pavilion was a formidable task, for no cranes existed that could lift the massive steel frame into position at the top of the support columns. Instead, the frame was assembled on the ground and then slowly raised into position using an elaborate set of jackscrews that required careful control to make sure the roof rose evenly. (Courtesy of John Pender.)

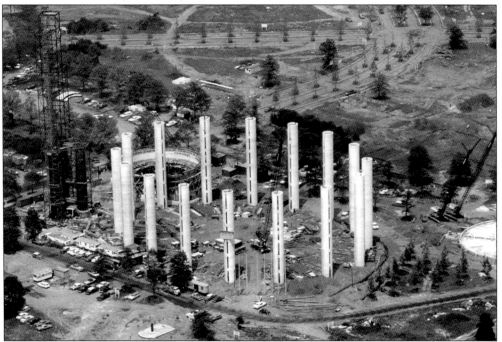

The columns of the New York State Pavilion stand like a modern-day Stonehenge in this view dated June 19, 1963. The darker columns on the left side of the pavilion eventually held the observation platforms, which were the highest points at the fair.

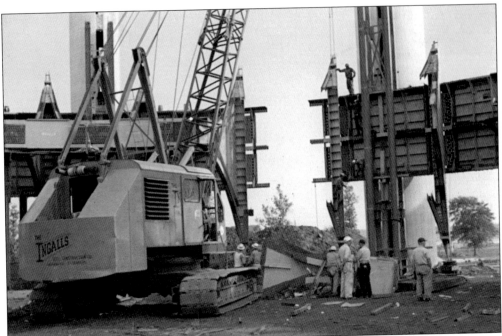

After the ring of 16 columns was erected, the next step was to build the steel frame that held the roof panels. Here construction workers prepare to insert the last section of the frame at ground level. (Courtesy of Karl Baker.)

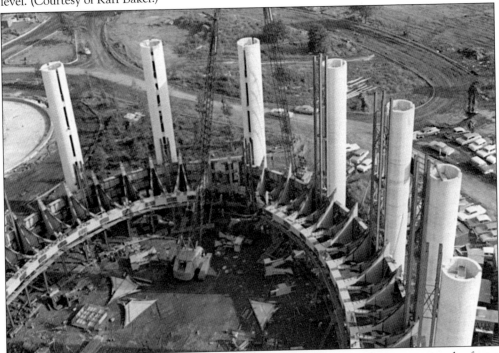

Temporary guide rails were installed on the inside of the concrete columns to raise the frame into position, much like railroad tracks on which a train rides. The oval outline of the Vatican Pavilion can be seen at the top of the picture. (Courtesy of Karl Baker.)

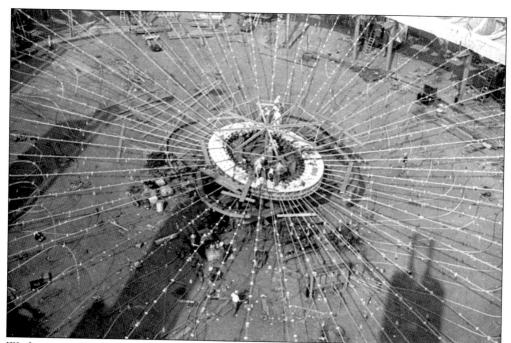

Workers ran cables from the frame to a central torsion ring. These cables held the roof panels, lights, and a drainage system to collect rainwater. (Courtesy of Karl Baker.)

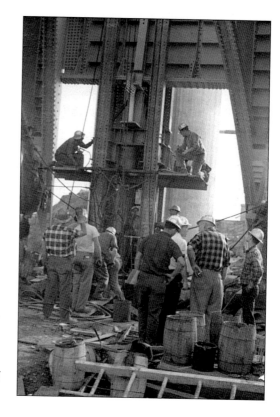

The frame was then lifted slowly up the columns, with workers carefully monitoring the progress and adjusting the position along the way. Temporary beams were used to hold the frame until it was finally slotted into position at the top. (Courtesy of Karl Baker.)

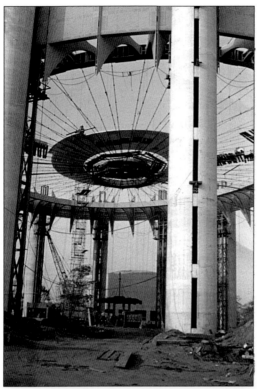

The 1,500 roof panels were then added, working from the center of the roof out toward the steel frame. Workers had to carefully balance themselves on the swaying cables, making the assembly a risky task. (Courtesy of Karl Baker.)

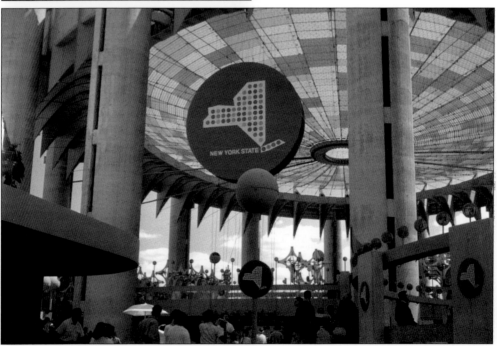

Building the roof of the Tent of Tomorrow was a lot of work, but the crowds who watched a steady stream of live shows under it surely enjoyed the result. The translucent panels seemed to glow both in sunlight and when lit at night, providing a feeling of warmth to the huge expanse below.

The construction of the observation towers at the New York State Pavilion allowed for some unique opportunities to photograph the work underway on the rest of the site. This view of the Unisphere shows how trucks, trailers, and other construction equipment covered the grounds, with dirt roadways making navigation even harder when it rained. (Courtesy of Karl Baker.)

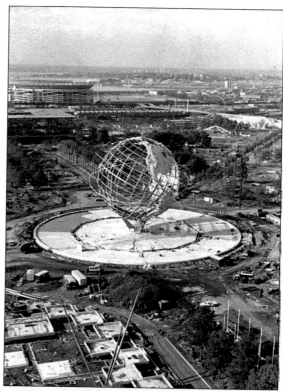

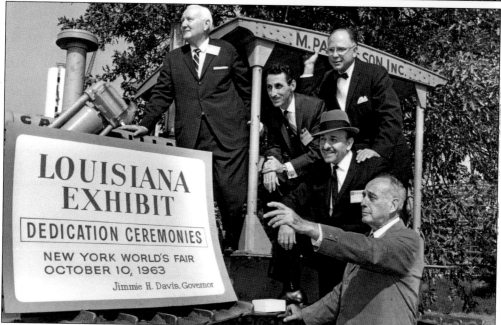

The New York World's Fair 1964–1965 Corporation took advantage of major milestones by staging photograph opportunities that were accompanied by elaborate souvenir booklets and press releases. Here Robert Moses hosts a delegation of officials from the state of Louisiana and city of New Orleans.

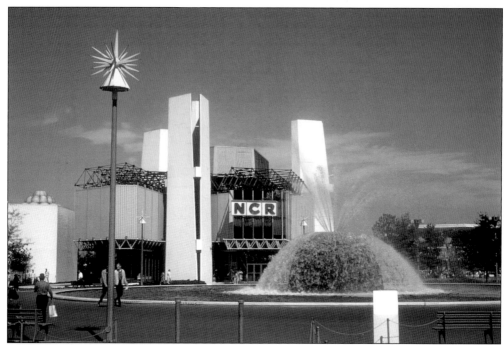

Many of the buildings at the fair broke new ground in terms of design. The NCR (National Cash Register) Pavilion, for example, was actually built from the roof down. The walls were supported from above, which created a large exhibit space free of supporting columns.

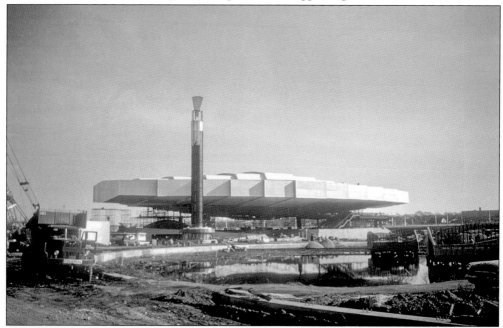

The Bell System Pavilion was another building that challenged its builders. The cantilevered main structure, which measured 400 feet long, 200 feet wide, and 87 feet high, was perched on four small pylons. The steel framework was built by a bridge company that had experience in erecting large, unsupported spans.

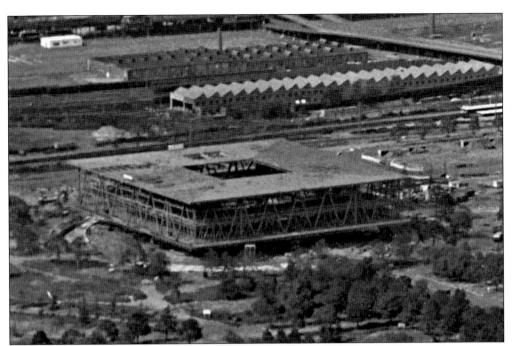

While the United States Pavilion may have looked like a large box on stilts, it was actually an engineering marvel. Like the Bell System Pavilion, it used a steel truss that was built by a bridge company, enabling the massive structure to seemingly float on its four small legs.

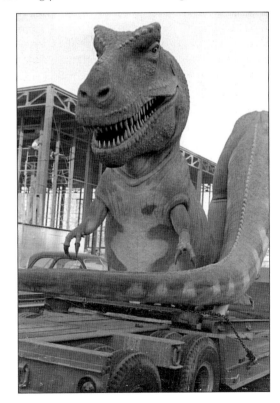

While work was underway on the pavilions, exhibits began arriving on site. One spectacular group of arrivals was the dinosaurs of the Sinclair Dinoland exhibit. After a barge ride down the Hudson River that stopped traffic as it passed, the fearsome tyrannosaurus rex made it to the fair, albeit in two pieces. (Courtesy of Karl Baker.)

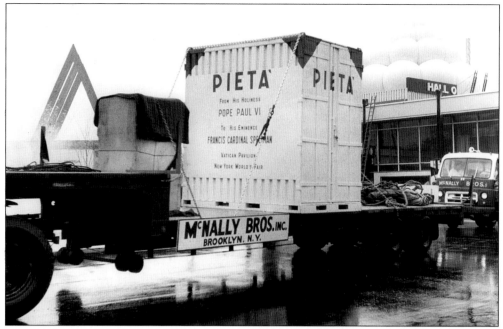

One exhibit that could not arrive in pieces was Michelangelo's sculpture the *Pieta*. On a rare loan from the Vatican, it was shipped to America in a special crate designed to protect the masterpiece even if the ship it traveled on sank. It safely survived the two years on exhibit and the return home. Between seasons, it was kept locked in a well-guarded protective cage.

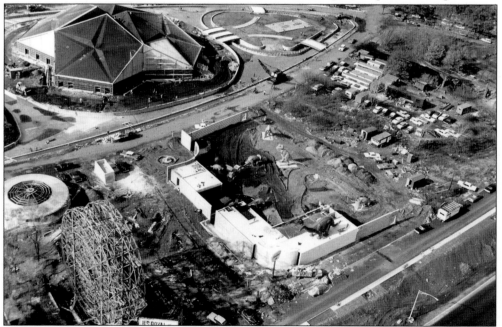

After their arrival at the fair, Sinclair Dinoland's dinosaurs were assembled and put into place on the grounds of the pavilion. Landscaping and paths were then added to complete the exhibit. The photograph shows the steel framework of the U.S. Royal Ferris wheel at lower left, the Chrysler Pavilion at top, and the beginnings of the Avis Antique Car Ride at the upper right.

40

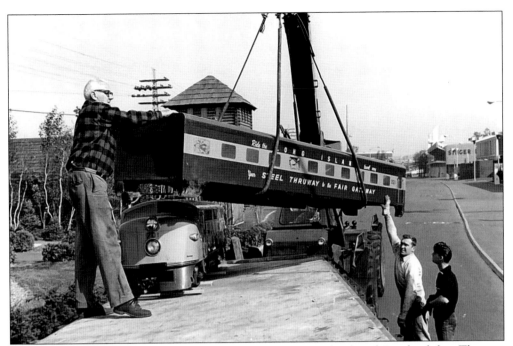

Workers unload the miniature train that circled the Long Island Rail Road exhibit. The cars carried the same paint scheme as their full-size counterparts, advertising the Long Island Rail Road as "Your Steel Thruway to the Fair Gateway."

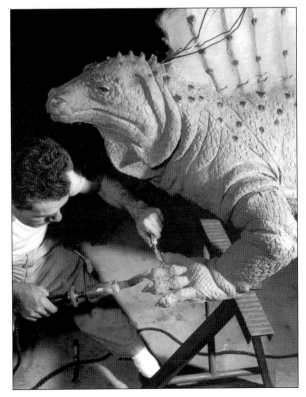

This dinosaur from the Ford Pavilion is ready to meet the public by getting a most unusual pedicure. An industrial-strength soldering iron was put into service when Disney imagineers needed to fix small holes in the creature's plastic skin.

41

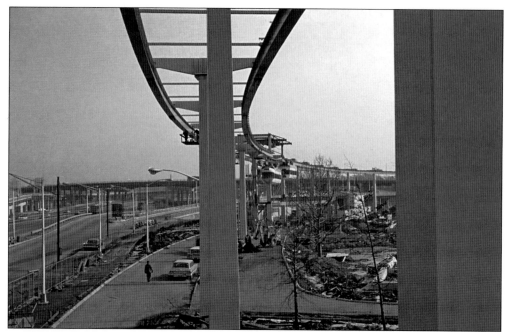

Ever wonder how to put a monorail car on a circular track with no beginning and no end? The ingenious answer is to use a section of track that lowers and raises like an elevator. Here the AMF (American Machine and Foundry Corporation) Monorail cars are being raised up to the track after their arrival from the factory in St. Louis.

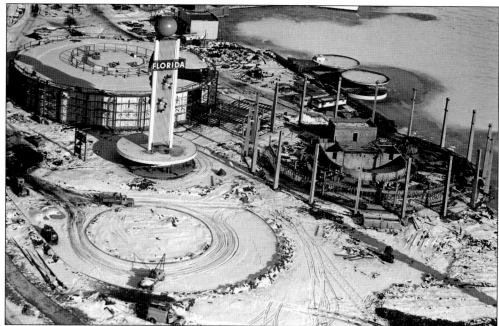

To get the fair open on time, construction crews had to work through the often-harsh New York winter. Pictured is work underway for the sunny state of Florida Pavilion while the pavilion's site is still covered by a layer of snow. The pavilion's tropical vegetation had to be replaced between seasons, and the performing dolphins were shipped back home for some well-deserved rest.

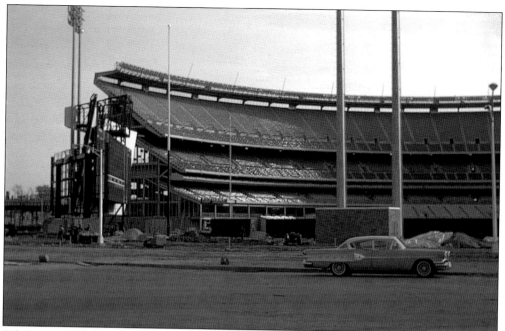

While most of the work was centered on the pavilions on the fairgrounds, work was also underway on the fair's neighbor, Shea Stadium. Besides being home to the Mets and Jets sports teams, the stadium was used for a number of world's fair events, including the famous Beatles concert in 1965, which began with the Fab Four arriving via the fair's heliport.

Here the staff of the fair's press building poses for a photograph. One of the first buildings completed for the fair, it turned out to be one of the longest to remain standing after the fair closed. It became a substation for the New York City Police Department and was utilized for over 30 years before being demolished to make way for an exit ramp off the Grand Central Parkway.

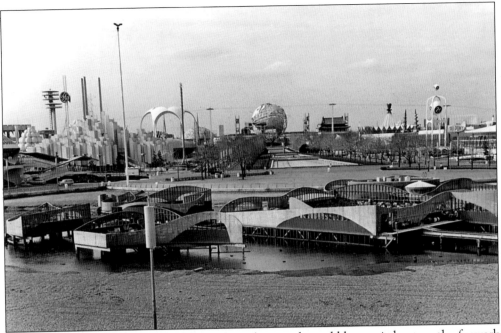

This view of the Fountain of the Planets shows how work would be carried out on the firework launchers and water jets once the fair was open. The pool was filled by water that was subject to tidal flows, so when the maintenance crews needed access, they closed the input valves, and the tide conveniently drained the water out of the pool.

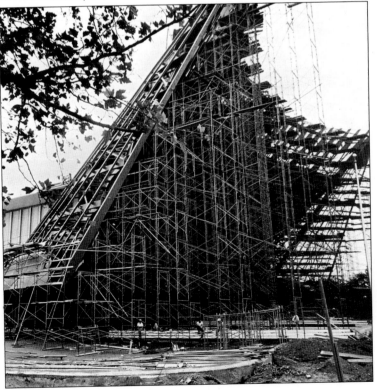

It is not surprising that news stories of the era commented on the shortage of construction workers and material throughout the area due to all of the work underway at the fair. Looking at the sloping entrance canopy of the General Motors Pavilion, it seems that scaffolds were one of the items much in demand.

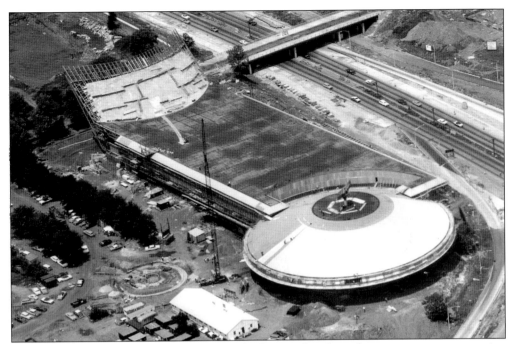

Building the General Motors Pavilion was such a large undertaking that a temporary construction building the size of an average warehouse was put on the site along with dozens of smaller shops and sheds.

More scaffolding stands next to the rotating frame of the Astral Fountain. Printed at the bottom of the sign was this interesting bit of advice: "This is a temporary construction sign." Signs like this were needed to help building crews identify where they were on the nearly one-square-mile construction site.

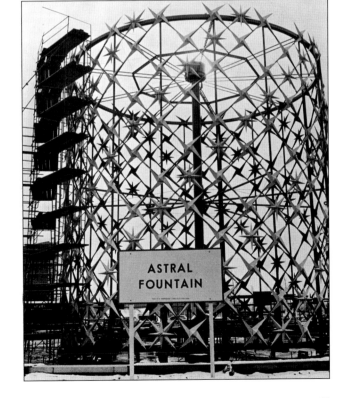

ASTRAL FOUNTAIN

45

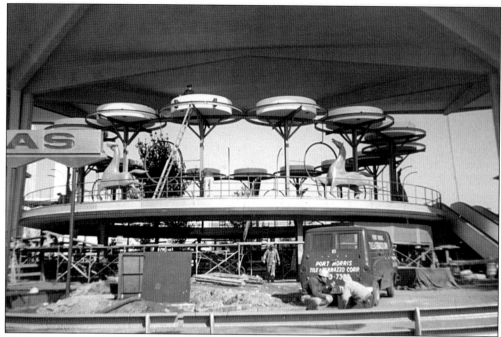

Work stops for a well-deserved lunch break outside the Festival of Gas Pavilion. Crews were called in from all around the metropolitan area, and special arrangements were made with labor unions to avoid strikes or slowdowns. (Courtesy of Karl Baker.)

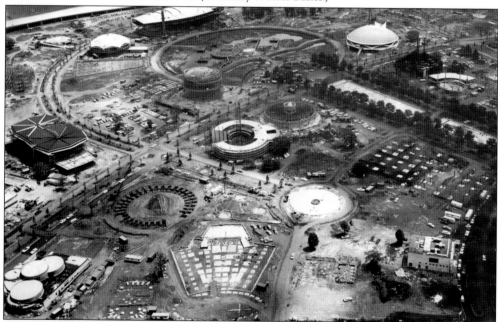

Getting the fair ready on time required a tremendous amount of planning and coordination. Some pavilions were ready well before opening day, while others scrambled to finish in time. In this aerial view taken on August 6, 1963, some pavilions, like General Electric and RCA, look ready to open, while others do not even have their foundations completed with a mere eight months to go until opening day.

The Belgian Village was one of the last pavilions to begin construction. This view of the snow-covered site was taken on January 17, 1964. With only three months until opening day, there was more work remaining to be done than had been completed.

This photograph, taken in July 1964, shows work still progressing on the Belgian Village. Groundbreaking for the exhibit had taken place on April 11, 1963, but the elaborate village did not open until August 4, 1964. Financial problems caused a series of construction delays. The Belgian Village was lucky; other pavilions that had lagged behind on construction were ordered demolished prior to opening day.

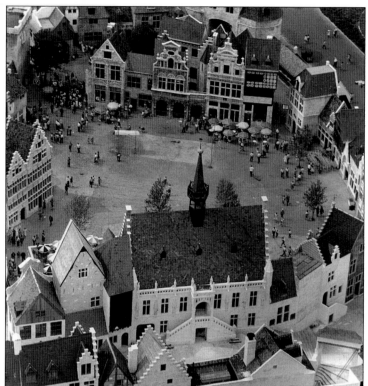

Once the gates were opened, the Belgian Village became a popular attraction even though a separate admission fee was charged. The sheer size and Old World charm proved to be popular, especially in the evenings when the restaurants and nightclubs drew steady crowds.

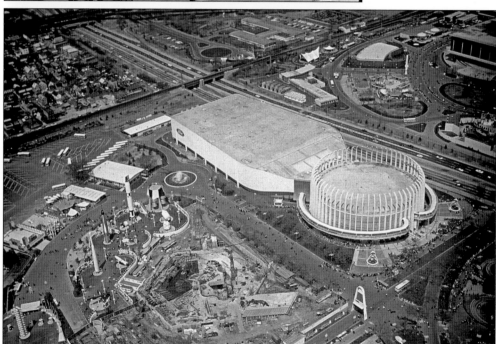

The Belgian Village was not the only pavilion not ready for opening day. Seen here in April 1964, the Hall of Science is barely underway. If it had not been planned as a permanent addition to the park, it is likely that the project would have been canceled before the fair opened.

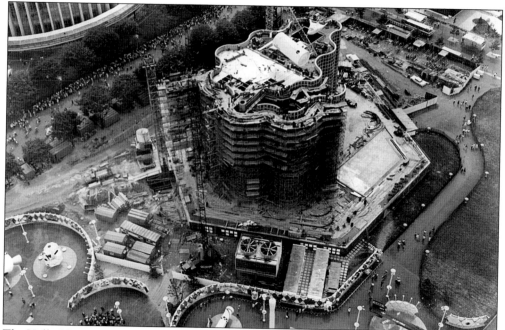

The Hall of Science did not officially open until September 9, 1964, although some of the exhibit space in the lower level was open to the public while work continued overhead. Long lines can be seen waiting to visit the Ford Pavilion, but the Hall of Science is a maze of construction equipment, concrete, and scaffolding.

It is less than a month before opening day, and there is still a lot of work to be done. Although the Port Authority Heliport had been one of the first structures to open, this crew is still working on the theater and Hertz counter at its base.

Finally, after years of planning and construction, it was time to tear down the security fencing and open the gates. Soon after this picture was taken, thousands of eager visitors explored the wonders of the fair.

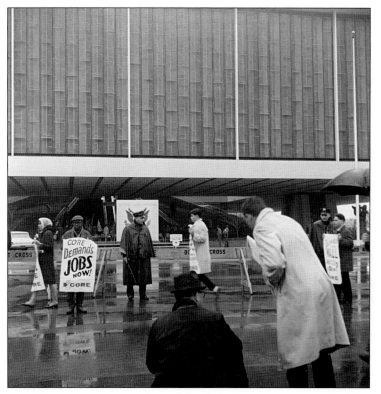

Opening day was rainy and beset by protestors who saw the fair as a means to gain attention for their feelings about racial injustice. Still, the fair was open, and millions of visitors saw it all for themselves.

Four

THE PHANTOM FAIR

We may proceed with the demolition of the World of Food Exhibit. Mr. Moses has decided that the structure should be demolished and the site landscaped prior to Opening Day.

—Gen. W. S. Potter, April 7, 1964

Everyone wanted to "Come to the Fair!" After all, it was going to be the *New York* world's fair. New York was the center of the universe in the mid-20th century. Headquarters to the United Nations, it was the world's capital. Home of the largest financial institutions and corporations, it was the economic center of the universe. To be a part of the New York world's fair was an expression of power and prestige. The opportunity to sell a message, a product, or a nation to 70 million projected visitors was a tantalizing prospect indeed.

Participation in the fair was an expensive proposition. Site rental and import duties on construction materials and exhibits had to be considered. Architectural and engineering fees, landscaping costs, and union labor to construct pavilions were other considerations. There were also the costs of operation once the fair opened, including staffing, grounds upkeep, and refuse removal.

The press reported with great fanfare the announcements of the New York World's Fair 1964–1965 Corporation. Week after week, new countries, states, companies, and organizations were signing on with the fair. Steadily the huge site map at the administration building began to fill with the names of exhibitors who had agreed to lease space. By the autumn of 1962, the map boasted such names as General Motors, the Soviet Union, Argentina, Mexico, Kodak, the World of Food, the Heartland States, Japan, Ecuador, and the State of Georgia, to name just a few.

Many of these grand ventures never came to fruition. Exhibiting at the New York world's fair was the dream of many, but in reality, it was simply too expensive for all but a few. Major exhibits, announced with great flourish, quietly disappeared from the site map with little or no comment. Some never got past the concept phase. Others, like the World of Food Pavilion, actually began construction only to be torn down. Still others scaled back participation when costs began to skyrocket or they changed their designs completely. These exhibits became part of a phantom world's fair—the fair that never was—that still lives on in vintage photographs.

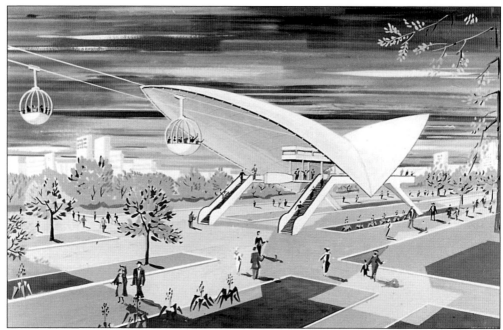

Some of the pavilions that made it to the fair started with designs that were very different from what was eventually built. This version of the Swiss Sky Ride featured large circular gondolas and a space-age station, while the actual ride used much smaller cars and fairly nondescript stations. (Courtesy of John Pender.)

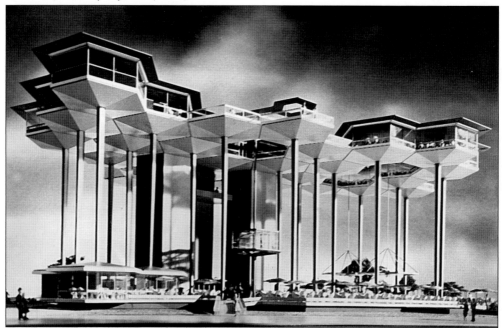

Visitors to the fair who enjoyed a beer in the quiet gardens of Rheingold's Little Old New York will undoubtedly be surprised to learn that this was the company's original design for its pavilion. Large elevators would have lifted guests up to platforms that offered views of the fair along with the beer. (Courtesy of John Pender.)

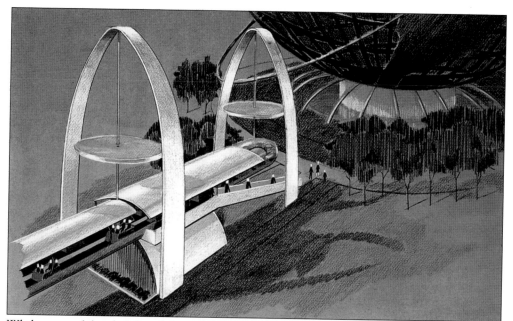

While some of the abandoned designs for the fair may have resulted in interesting buildings or rides, it is perhaps fortunate that others never came to fruition. Such is the case of Goodyear's proposed Carveyor, which would have carried guests from the main entrance across the grounds to the Unisphere. The large structure would have been a visual nightmare, blocking views of many of the pavilions along its route. (Courtesy of John Pender.)

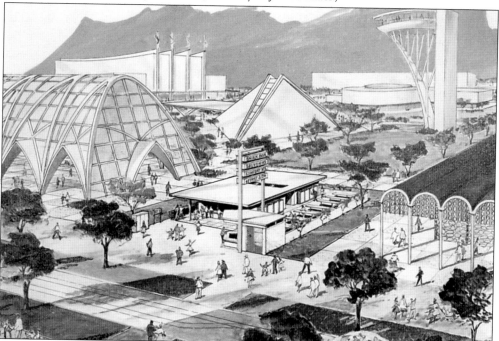

This early design for "Snack Bar and Comfort Station" does not bear any resemblance to the balloon-topped Brass Rails that were scattered across the fairgrounds—but then again, none of the other pavilions pictured here were ever built either. (Courtesy of John Pender.)

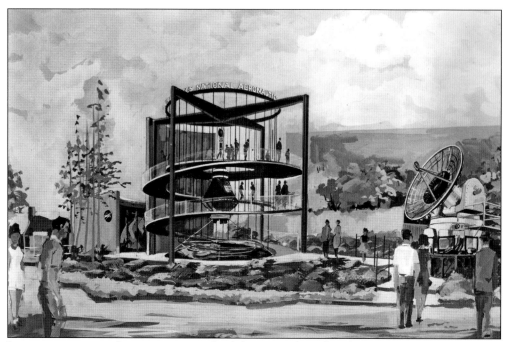

It was not surprising that many potential exhibitors tried to take advantage of the interest in the ongoing space race. This design was for the Texas-NASA Pavilion. It featured a spiral ramp that would have provided close-up views of a Mercury space capsule.

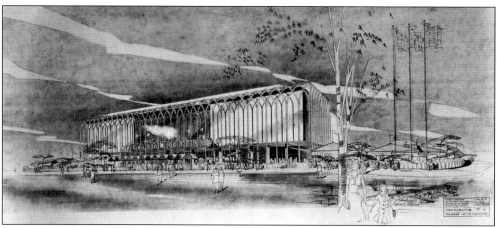

A number of prominent architectural firms worked on pavilions that never were built. This design for Century Showcase, a theater and restaurant complex, was created by John Graham and Company, which had earlier designed the famous Space Needle for Seattle's 1962 world's fair.

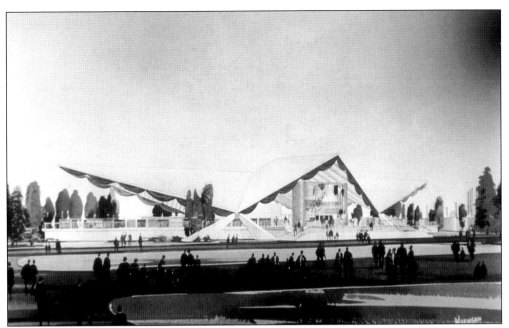

The World's Fair Assembly Pavilion was intended to be used as a multipurpose hall for groups or events too small to host their own pavilion. A much simpler geodesic dome was eventually built, along with a much simpler name—the Pavilion.

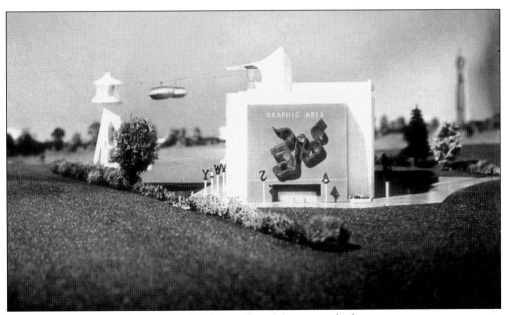

The Graphic Arts Pavilion featured a design that did not match the many space-age structures built for the fair. Instead it resembled pavilions from the 1939–1940 New York fair. Few details were provided as to the potential exhibits inside, but the design made it into many early New York World's Fair 1964–1965 Corporation promotional materials.

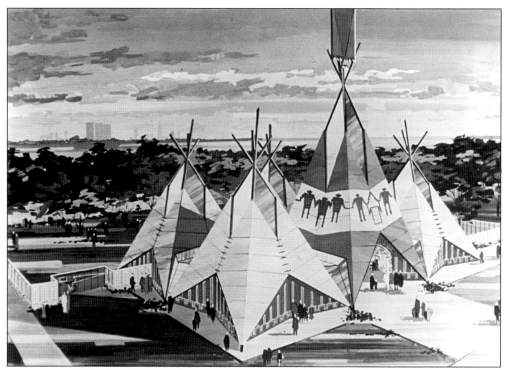

The American Indian Pavilion was planned to be built by a number of tribes and would have offered displays about their heritage, as well as a dance area, shops, and a restaurant.

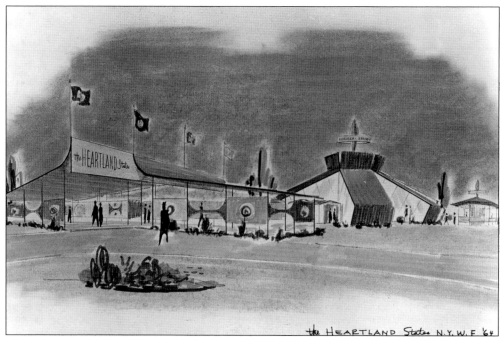

The Heartland States Pavilion was another collective effort and would have been sponsored by the states of Iowa, Kansas, Minnesota, Missouri, Nebraska, North Dakota, and South Dakota.

Another group of states was behind the extremely ambitious Rocky Mountain and Southwestern States Pavilion. The giant man-made mountain would have hosted exhibits both on the slopes and in a cavernous interior. (Courtesy of John Pender.)

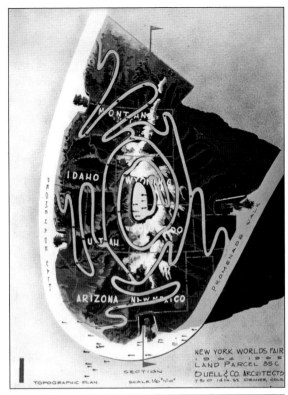

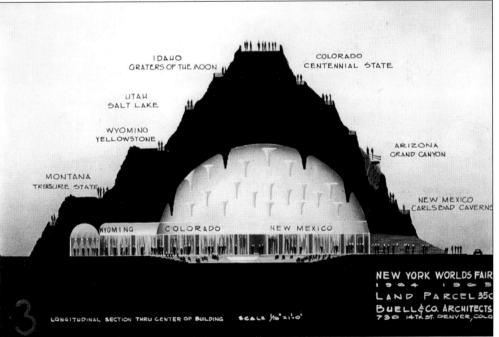

Larger than Disneyland's Matterhorn, the pavilion would have contained an auditorium where groups from the sponsoring states would have performed on a daily basis. (Courtesy of John Pender.)

The Marine Center was another ambitious venture. Built around a man-made lake, the 130,000-square-foot complex was to have included a lower level allowing guests to see underwater exhibits in the lake through a glass wall. If the pavilion had been built, it would have changed the look of Flushing Meadows-Corona Park forever, for it was slated to be built in the space eventually used by the Hall of Science.

Construction actually began on the World of Food Pavilion, but it never opened to fairgoers. Unhappy with the pace of the construction effort, fair officials feared that the building could not be completed by opening day, so they ordered the partially completed building demolished. A series of court battles ensued, and when they ended, the pavilion had been reduced to a pile of steel beams stored in Brooklyn.

The fair made a concerted effort to attract international exhibits. However, a disagreement with the Bureau of International Expositions (BIE), the international governing body for world's fairs, meant that many governments were reluctant to participate. A special team concentrated on South American countries, and they almost succeeded in getting Chile to join the fair.

Senegal was among the countries that were listed as future participants at the fair. A number of African nations wanted to showcase their new independence there, but finances caused most of them to abandon their individual pavilions, though some participated in the eventual Africa Pavilion.

The United Nations Pavilion would have provided its smaller member nations an opportunity to appear at the fair, along with exhibits on the organization's goals and programs. The United Nations did have a pavilion, but only because it took over the failed Sierra Leone Pavilion for the 1965 season.

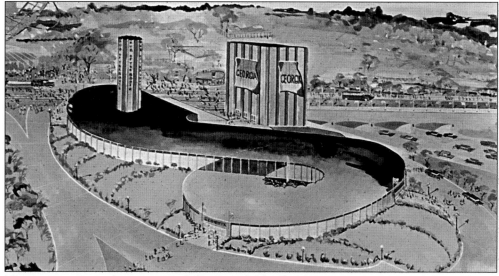

Many states expressed interest in exhibiting at the fair, hoping to attract new tourists or potential investors. One state that had grand plans was Georgia, which reserved a prime 69,584-square-foot plot near the Unisphere. Another victim of insufficient funding, the project did not progress much past the initial design stages.

Five

PROMISES OF THE FAIR

*I'm not prepared to say what the main theme will be. But I can say
that space and electronics will be emphasized.*

—Robert Moses, *New York Journal-American*, June 12, 1960

A machine that mows down the jungle and creates a superhighway in its wake, moon bases, and undersea hotels—General Motors' Futurama promised that concepts like these were already "beyond the promise and well on their way." Critics pointed to General Motors' fantastic ride into the future as proof that this fair was somehow less worthy than its 1939 predecessor. Many of the predictions for "the world of tomorrow" made by the 1939 fair were sound and came true. Were the promises made by the 1964 fair fulfilled or did it simply have its head in the clouds as its critics' claimed?

NASA's U.S. Space Park showed fair visitors the route America was taking to put a man on the moon by the end of the decade. Neil Armstrong placed his one small footstep there on July 20, 1969. IBM predicted that the computer age was dawning. Its Information Machine explained the complexities of computer logic to the ordinary citizen. Today that ordinary citizen is apt to have a personal computer in his or her home. NCR showed how microfiche was miniaturizing the written word so that it could be economically stored. Greyhound prepared meals for its restaurant patrons using a new device called the Radar Range that used microwaves to cook food in minutes. The Bell System exhibited the recently launched communications satellite Telstar and said that this was just the beginning of a revolution in satellite communications that would shrink the world even more than the dawn of jet travel in the decade before.

West Virginia presented a film about the new $850,000 radio telescope at Green Bank that described how it probed for the secrets of the universe. The SETI (Search for Extra-Terrestrial Intelligence) project still uses the Green Bank radio telescope to search the heavens for answers to humanity's questions. Traveler's Insurance showed how mankind struggled to survive through the ages. Americans continue to purchase insurance to protect them from calamity. Despite the claims of critics, many of the fair's predictions are taken for granted today in the world of the 21st century.

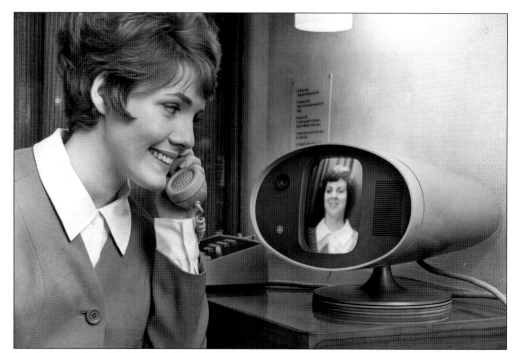

Read an article today on the fair and it will almost always mention the failure of the highly promoted Picturephone. AT&T had high hopes for the system and continued working on the project until they made it commercially available in 1970. By 1974, they had pulled the cord on the venture.

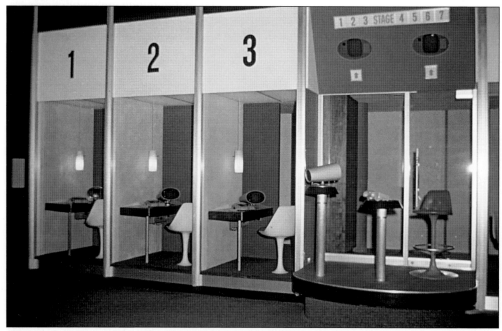

This is the Picturephone demonstration area, located in the lower level of the Bell System Pavilion. Visitors could see other callers at the fair or at Disneyland. However, the few users who could afford to use the system soon tired of the novelty of staring at people staring back at them.

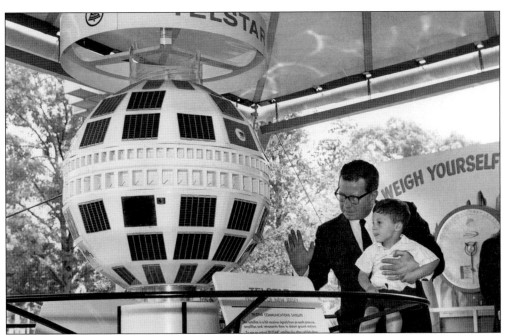

Set in the fast-paced days of the space age, the fair showcased new technologies that are now commonplace. Here Gov. Richard J. Hughes of New Jersey shows off Telstar, which greatly increased the ability to send video and other data between far-flung nations. Taken for granted now, audiences in New York in 1964 were thrilled to be able to watch live programming from England.

General Electric offered the promise of bountiful energy through the wonders of nuclear fusion. Demonstrations were held that produced a great deal of noise, light, and public interest, but homes have yet to be powered by the promised marvel.

63

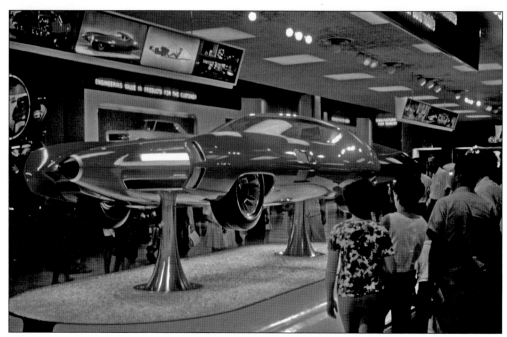

All three of the American automobile makers at the fair exhibited concept cars that intrigued guests with promises of space-age vehicles soon to come. General Motors led the way with sleek mock-ups, such as the streamlined GMX. Little more than a plastic shell, it still drew steady crowds who were probably picturing how it would look in their driveways.

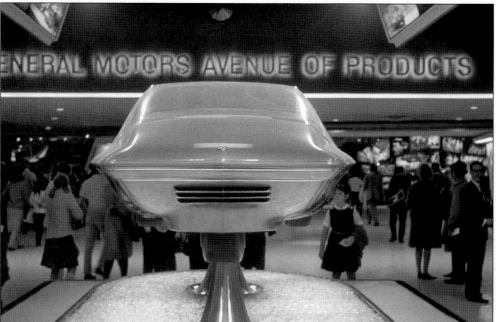

General Motors also exhibited this mock-up of a small three-wheeled car that was aimed toward housewives. The display promised that the three-wheel design would allow for easy parking while out shopping, and the rear hatch opened to show a load of groceries neatly stacked inside, with space for more.

The focal point of the Hall of Education was a presentation of education envisioned for the future, featuring a nine-foot-tall model of the school of the year 2000. The exhibit's designers predicted a workday averaging four hours, which would provide parents more free time to spend with their children on education. The School of Tomorrow and the four-hour workday are still only a designer's dream.

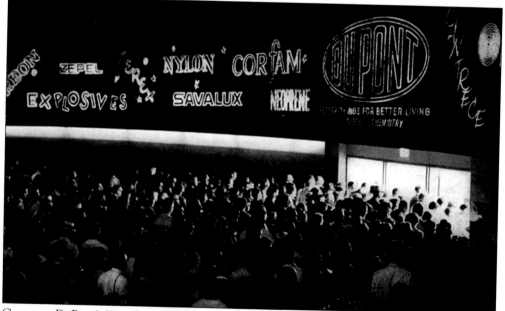

Guests at DuPont's Wonderful World of Chemistry were treated to previews of new products, including Corfam, an imitation leather introduced with the same level of hype as Nylon, which DuPont debuted at the 1939 world's fair. DuPont trumpeted Corfam's durability and high-gloss finish that could be easily cleaned. However, it did not breathe like real leather, so it made feet itch and was resoundingly rejected by consumers.

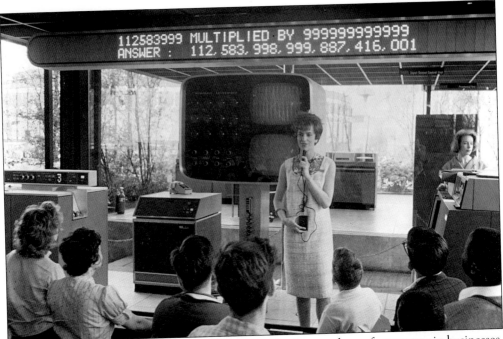

One of the things the fair did predict correctly was the increased use of computers in businesses, schools, and homes. Several pavilions featured films or demonstrations, such as this one at the IBM Pavilion proclaiming the benefits of these electronic brains.

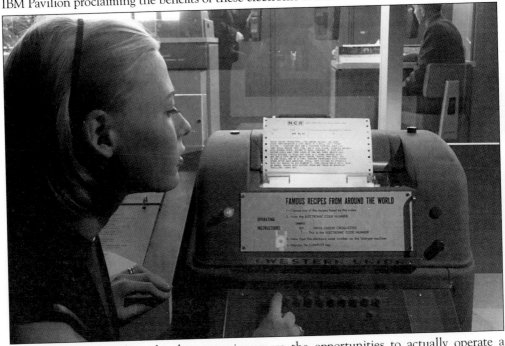

Even more exciting than the demonstrations were the opportunities to actually operate a computer, something that very few people had done in 1964. Terminals at the NCR Pavilion, for example, let guests retrieve 315 different recipes, look up facts about a date in history, or request tourism data.

NCR predicted a very different type of computer would soon be available. Instead of using wires or gears, their system was to be based on something called "fluid logic" that used liquids coursing through a maze of tubing and valves. As history has proven, the technique could not match the speed of silicon-based systems.

NCR had better luck with its system that could scan a printed number and turn it into a computer code. Commonly known today as Optical Character Recognition, or OCR, the technology allowed for the rapid input of data without human intervention, greatly increasing the implementation of many new computer applications.

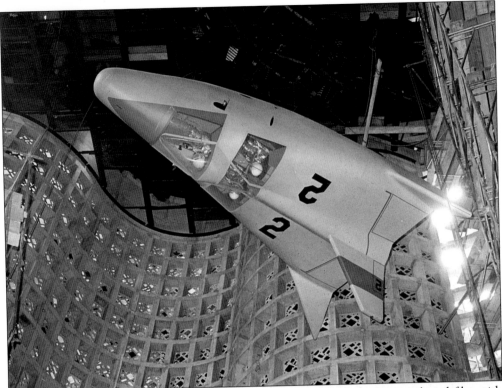

The Great Hall at the Hall of Science featured a multimedia show that combined film with models such as this futuristic crew module. The design is known as a lifting body, and while these crafts proved to be quite unstable, valuable lessons were learned that were incorporated into the design of NASA's space shuttles.

By 1964, airlines were already looking beyond the advent of the jumbo jet to the next advance in commercial aviation—the supersonic transport or SST. Trans World Airlines (TWA) displayed a concept model as part of its world's fair exhibit in the Travel and Transportation Pavilion. The British, French, and the Soviets eventually built SSTs, but they were never the commercial success envisioned. The SST and TWA have both disappeared in the years since the fair.

Appliance manufacturer Norge claimed that the increased need for disposable everyday dishes would be met by the Dishmaker. Shaped like an ordinary kitchen cupboard, the Dishmaker molded plastic dishes at the push of a button. There would no longer be dishes to wash, dry, put away, and take up storage space; simply use them once and throw them away. In the pre–Earth Day era, environmental issues were not considered.

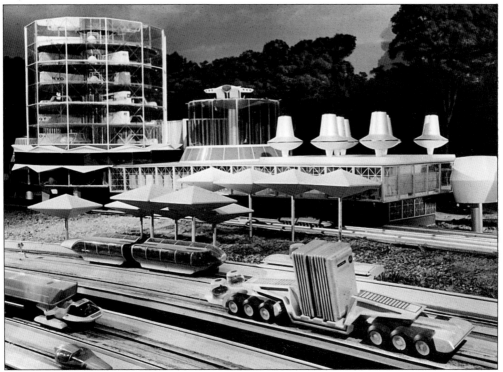

No one made more predictions for the future than General Motors, and no one got so many of them wrong. This section of the Futurama ride featured a computerized highway that automatically spaced cars at safe distances, thereby reducing traffic jams and accidents.

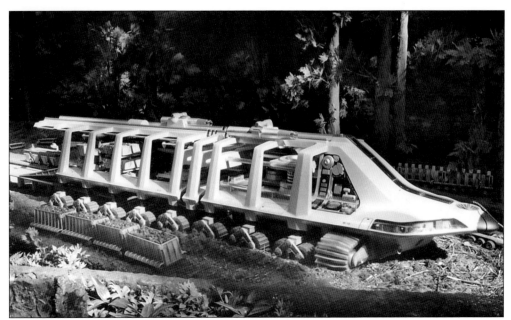

This futuristic machine would have brought tears to the eyes of any environmentalist, for it was described as being able to crawl through virgin rain forests and leave a paved road behind it. Back in 1964, the automobile was king, and General Motors was the leader of the automotive world. Highways everywhere were seen as the way to bring the wonders of civilization to even the most remote outposts.

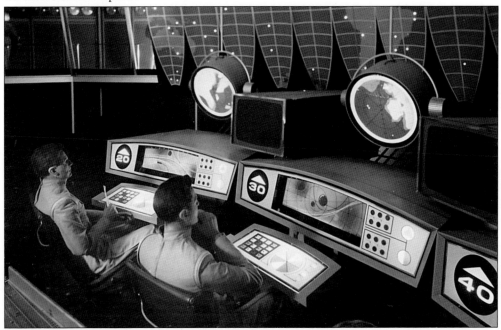

The world of the future would still have inclement weather, but humans would be better prepared for it because scientists in cozy laboratories beneath the polar ice caps would monitor the climate to better predict storms. Would they have predicted global warming and the melting of their own protective ice homes?

Six

THE CHANGING FAIR

Nothing endures but change.

—The Greek philosopher Heracletus, some 2,500 years ago

Before the first guests enjoyed their visits to the fair, some of the best minds in industry and entertainment had worked for years to create the pavilions, shows, and other attractions assembled at Flushing Meadows Park. With the eyes of the world on their efforts, no expense was spared to ensure that these visitors would have the best-possible experience, with millions of man-hours all focused on making sure that nothing was left to chance. Right?

Wrong. Despite having several years to hone their plans, the designers of many pavilions soon found that they had missed the mark. In some cases, one has to wonder what they were thinking of and who approved spending money on projects that seemed doomed from the start. For the worst of these ventures, frantic efforts to turn things around began almost as soon as the fair opened, while other changes were more subtle and introduced slowly over time. Some parts of the fair, particularly the live stage shows such as *To Broadway, With Love*, were beyond hope and had to close their doors. Sometimes completely new attractions were rushed into production to replace dismal failures. Some attractions were luckier, benefiting from the fine tuning and enjoyed at least some level of success.

Not all of the changes made during the two years of the fair were due to design failures. Some exhibitors found themselves needing to adapt to an unexpected but welcomed crush of visitors flocking to see their shows. Other shows were updated to reflect new product advances made between the seasons.

Tracking all of these changes can be a challenge since most pavilion owners were understandably reluctant to draw attention to the less successful elements of their ventures. In some cases, such as the complete closure of a pavilion, news reports detailed the grisly failure, especially in media outlets that had previously predicted doom and gloom for the fair. Press releases were proudly issued for new pavilions and shows or for some of the improvements made to accommodate larger crowds. But for many others, the changes can only be seen by comparing photographs of the fair taken over the two-year run.

Some of the first pavilions to close featured live stage shows such as the Texas Pavilions' *To Broadway, With Love*. Backers of these shows had high hopes before opening day, but they all suffered from dismal attendance right from the start. With free entertainment readily available, fairgoers had little incentive to pay extra for shows that could not measure up to those on nearby Broadway. The show lasted only 97 performances.

After the money ran out and the backers pulled the plug on the stage show, the rest of the Texas Pavilions sat mostly empty despite several attempts to find new uses for the facility. Projects as varied as a discotheque and a game arcade all faired poorly, leading to the closure of nearby snack bars and souvenir shops. At times the area was all but deserted, as seen in this view from the AMF Monorail.

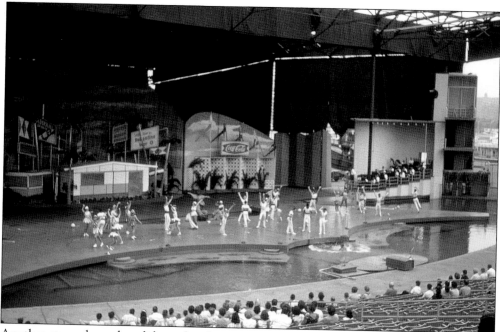

Another stage show that did not last long was Leon Leonidoff's *Wonder World*. Located in the Amphitheater, the show featured synchronized swimmers, high divers, dancers, singers, and even a man flying with a jet pack. But it did not have a plot, and the doors closed after less than three months. The Amphitheater stood empty for the rest of the 1964 season.

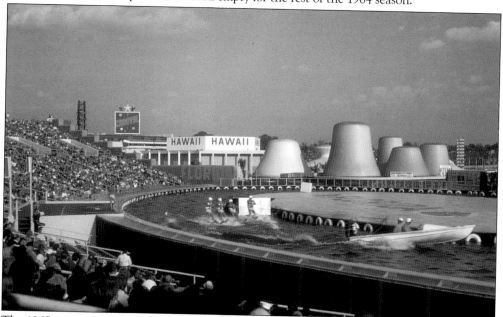

The 1965 season brought a very different look and audiences to the Amphitheater. The facility was completely remodeled to host the Florida Water Ski Show. Created by the operators of Florida's venerable Cypress Gardens attraction, the show was a huge success, and crowds lined up to watch a mix of waterskiing tricks and high-powered speedboats. The fact that it was free undoubtedly helped make it more successful than *Wonder World*.

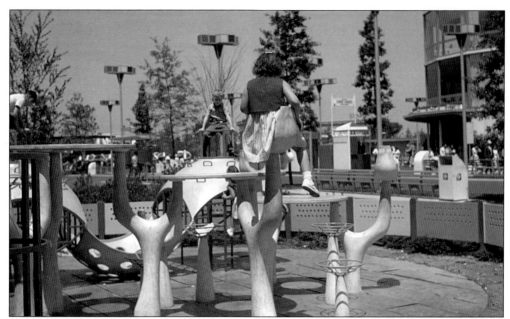

How would young visitors want to spend their summer vacation days at the fair? It certainly was not at the Hall of Education. The pavilion, which was primarily a series of displays from vendors like yearbook companies and cap and gown manufacturers, limped through the 1964 season with little to offer to the average guest and did not return in 1965. This playground was perhaps the only popular part of the pavilion.

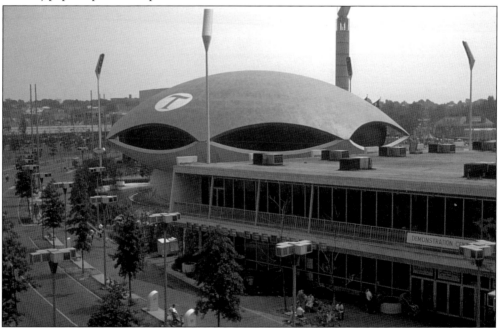

The second year of the fair found a new tenant for the facility, the Demonstration Center, which somehow made the Hall of Education look good. One of the more lackluster parts of the fair, the Demonstration Center was little more than a completely mismatched collection of small vendors hawking less-than-memorable products.

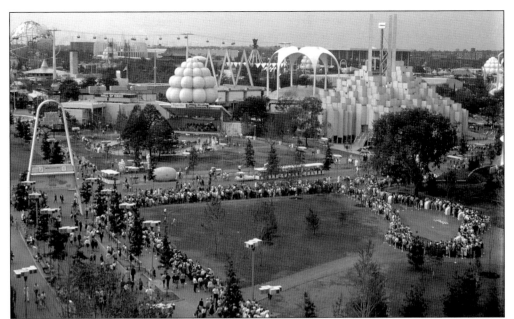

Not all of the changes at the fair were due to failures. Right from the start, General Electric's Carousel of Progress attracted huge crowds that were amazed by Disney's new Audio Animatronic figures extolling the wonders of electricity. The mass of guests waiting to get inside spilled completely out of the planned waiting area, and long lines snaked through any empty area near the building.

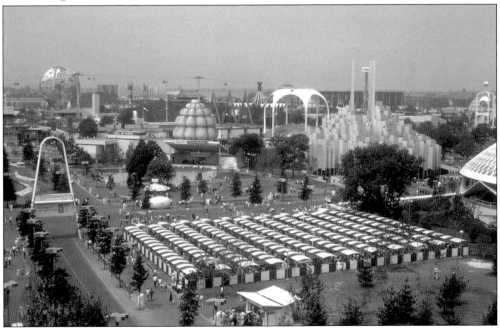

The second season saw a much more pleasant experience for those waiting for the General Electric show. A covered waiting area helped keep crowds in check, reduced problems with those trying to sneak to the head of the line, and, most importantly, kept people out of the harsh New York sun for waits that could easily exceed an hour.

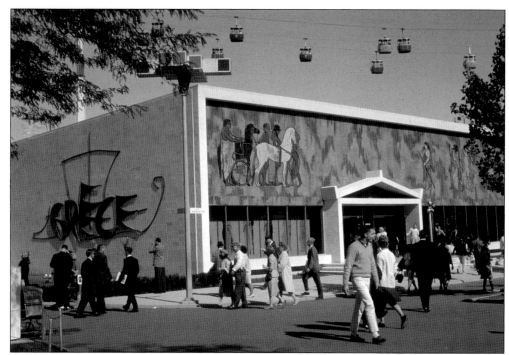

When the fair first opened, the Greek Pavilion featured a colorful mural atop a long row of windows. Unfortunately the sunlight coming in through those windows made it difficult to see the exhibits inside, and most pictures of the pavilion show them covered with heavy curtains.

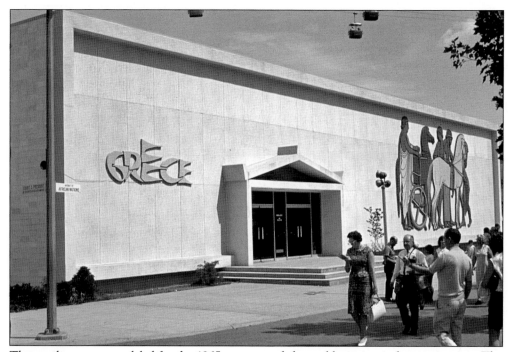

The pavilion was remodeled for the 1965 season, and the problematic windows were gone. The mural was lost in the process, leaving a rather plain wall in its place.

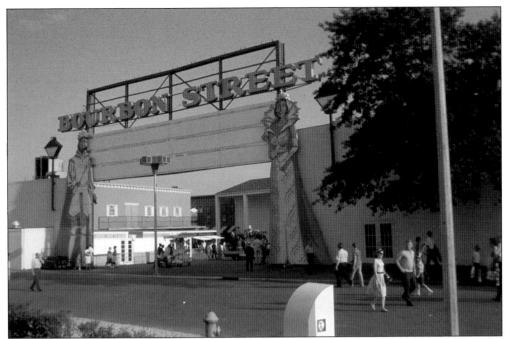

The design of Bourbon Street was quite bland, with long, empty walls greeting those passing by. First opened as Louisiana's Bourbon Street, the name was changed soon after the fair opened to just Bourbon Street following a falling out among the backers.

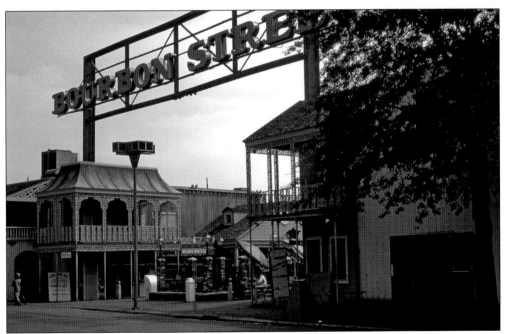

Hoping to attract more visitors to the shops and restaurants inside, the pavilion owners upgraded the entrance with a design that featured elements of New Orleans architecture. The makeover did not extend much past the entrance area though, leaving the pavilion as one of the least-imaginative structures at the fair.

Although the fairgrounds were generally deserted and quiet between seasons, work did take place in many areas to improve the pavilions for the second year. Here a delegation from Oklahoma makes its way through the snow-covered landscape that would soon see the addition of a popular Chicken Delight restaurant among other changes in 1965. (Courtesy of John Pender.)

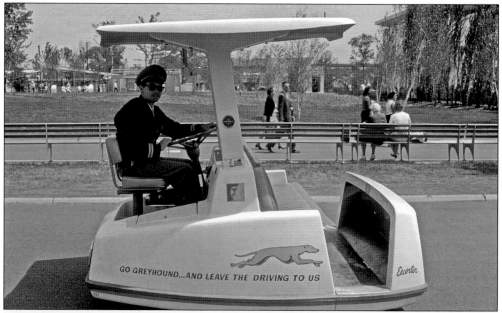

This unique vehicle was known as the Greyhound Escorter. It was designed to be a sort of futuristic rickshaw or pushcart. Guided tours were available to those who could afford to hire the Escorter and its driver, and they can be seen weaving through the crowds in pictures from 1964. The following year, they were all gone because they proved to be too expensive for most fair guests to hire.

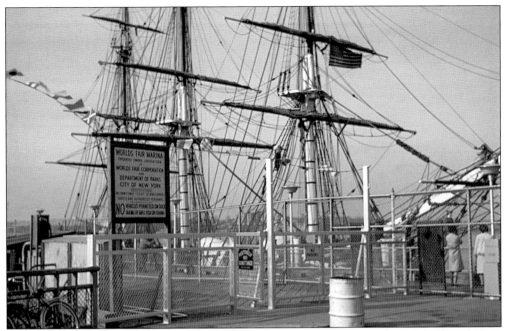

Another vehicle that was only at the fair for the 1964 season was this replica of the famed HMS *Bounty*. The ship attracted very few visitors, for it was not easy to get to the marina where it was docked, which was far from the main fair site. The owners instead moved it to a more successful home in Florida. The ship is still sailing today, usually on the East Coast.

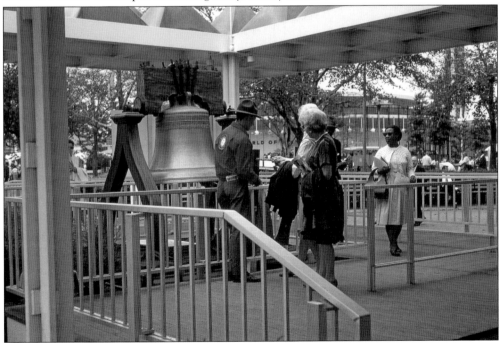

Not all of the changes between seasons saw the removal of exhibits. This replica of the Liberty Bell was added in 1965. The open-air attraction was small by any standard, and it was called the Pennsylvania Exhibit, not even earning the more common "pavilion" designation.

Some of the changes occurred before the fair had even opened. This view of the New York State Pavilion's Theaterama building shows an artwork covered by a black tarp. Underneath it was *Thirteen Most Wanted Men* by Andy Warhol. It was ordered covered by Robert Moses, for most of the faces were readily identifiable as Italians. The work was later painted over and remained that way for the rest of the fair.

Politics and financing woes led to the early closure of the Indonesia Pavilion, one of the most beautiful international pavilions. Faced with several months of unpaid rent bills, the fair corporation ordered the pavilion closed for 1965. For the rest of the fair, the building stood empty, with a simple set of barricades blocking the entrance.

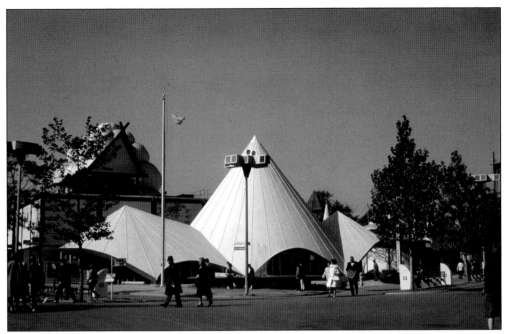

Sierra Leone was another international exhibitor that ran into financial difficulty. Money got so tight in 1964 that staff members were unable to pay their apartment rents and began living at the pavilion. The 1965 season saw the building being reused as the new United Nations Pavilion, sporting a bright blue paint scheme and United Nation flags.

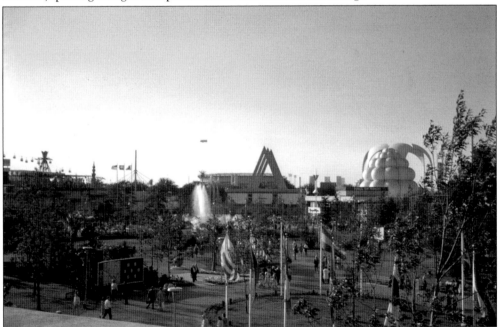

In 1964, the Pan American Highway Gardens was a tranquil area comprised of curving walkways that wound their way between displays about the highway through Central America. In 1965, the walkways were gone and go-karts raced along the new Pan American Highway Ride, sponsored by Avis.

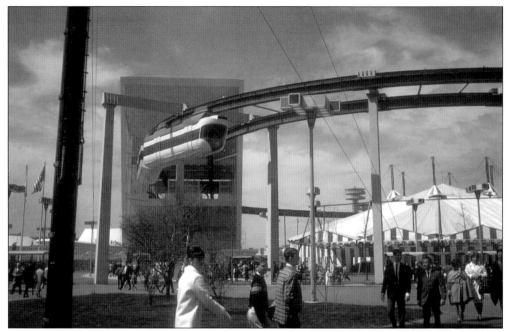

Another failure in the Lake Amusement Area was the Continental Circus, seen here beneath the AMF Monorail beam. When the circus left town, it was replaced with the type of rides that could be found in kiddie parks across the country, so the area was generally deserted and forlorn.

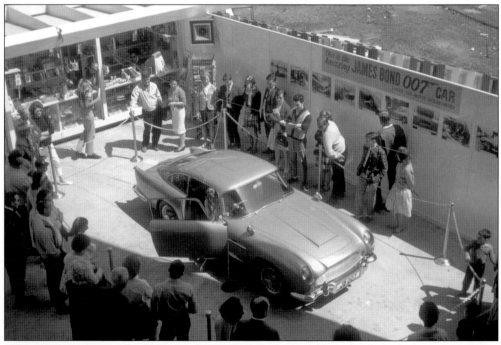

One popular addition for 1965 was James Bond's Aston Martin DB5, fresh from its starring appearance in *Goldfinger*. Shown as part of the AMF exhibit, it attracted large crowds anxious to see the hidden machine guns, ejector seats, and other spy gadgets.

Seven

THE FAIR ON SALE

World's Fair Monorail
Available Nov. 1st
Used just two summer seasons!

—Advertisement, *Wall Street Journal*, August 31, 1965

On the morning of October 18, 1965, just hours after the last guests had finally left the grounds, workmen arrived on site to begin the demolition process. With millions of dollars invested in what were now obsolete pavilions and shows, the fair's exhibitors were eager to salvage whatever they could in order to recoup their investments. Quite literally, the fair was now on sale to the highest bidder.

Tables, chairs, display cases, tons of structural steel, Pakistani saris, Montana elk, and the IBM People Wall—all were available to anyone with cash in hand and the means to haul them away. The AMF Corporation was willing to part with its $5.5 million monorail for just 20¢ on the dollar. Greyhound sold all 62 of its Glide-a-Ride trains to 29 different buyers. The Cockaigne Ski Resort near Jamestown, New York, picked up the Austrian Pavilion for $3,000 (but paid $190,000 in transportation fees). Ivan Wilcox and his sons dismantled and snuck the Wisconsin Pavilion out of the fairgrounds on a flatbed truck before union demolition workers even noticed. And there were hundreds and hundreds of multicolored streetlights waiting for someone to give them a new home. It is little wonder that this "greatest sale of surplus goods since the big postwar auctions of military gear" (as *Time* magazine put it) would result in bits and pieces of the fair being scattered throughout the country and around the world.

Some parts of the fair, such as the Christian Science Pavilion, which was shipped via the Panama Canal all the way to Poway, California, to become a church, and the Traveler's Insurance exhibit, the Triumph of Man, which was relocated to the Center of Science and Industry in Columbus, Ohio, have since been destroyed and are lost to history. Other pieces of the fair have become part of private collections where they are treasured mementoes of the past. Many world's fair legacies can still be seen and visited today, and fans of the fair continue to enjoy the thrill of new discoveries.

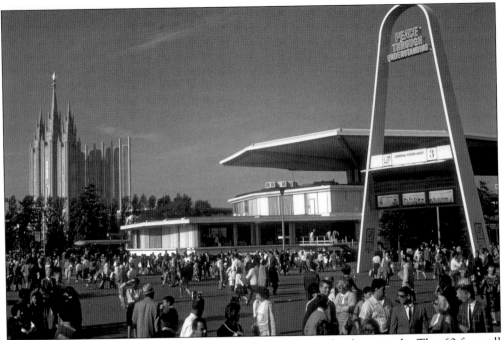

General Foods operated 11 information arches throughout the fairgrounds. The 60-foot-tall structures were equipped with electronic message boards, which offered information on live shows, operating hours, and other items of interest to guests.

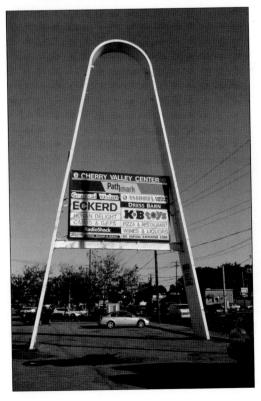

Five of the arches have been located since the fair closed. In addition to this one at a shopping mall in Hempstead, New York, there are two at a quarry in Huntsville, Ohio, one at the Enchanted Forest Park in Old Forge, New York, and one at the defunct Rocky Point Park in Warwick, Rhode Island.

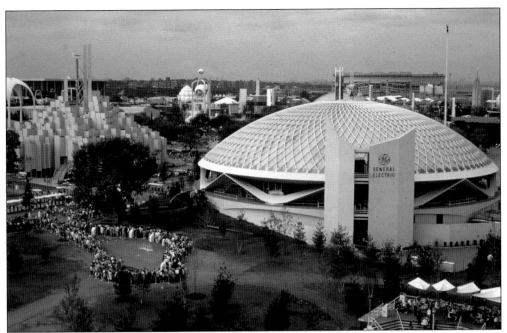

While most exhibitors saw no use for their shows after the fair ended, Walt Disney had always planned that all four of his world's fair shows would be moved to Disneyland. The long lines waiting for the Carousel of Progress and *It's a Small World* helped him secure corporate sponsorship to offset the costs involved in moving them, making the fair a lucrative venture for Disney.

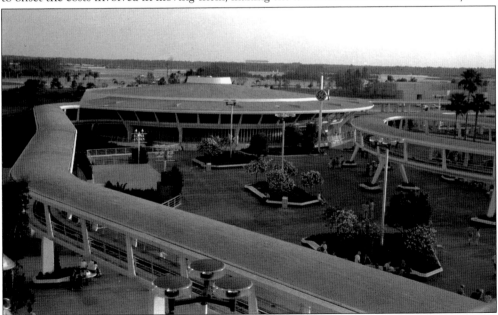

The Carousel of Progress reopened at Disneyland in 1967, still sponsored by General Electric, and ran there until 1973. It was then moved to Walt Disney World, as seen here in 1975. Unfortunately, the multicolored roof of the fair was not included in the theme park buildings. Still operating today, the Carousel of Progress currently holds the record as the longest-running stage show, with the most performances in the history of American theater.

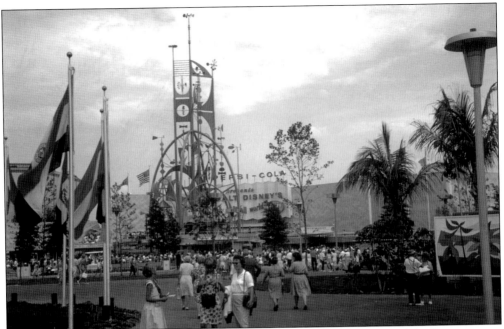

Disney's *It's a Small World* at the Pepsi Cola Pavilion was one of the major hits of the fair, attracting long lines of crowds of people who may still have the theme song stuck in their heads. While waiting to board "the happiest cruise that ever sailed 'round the world," they were entertained by Disney characters or the wind-powered mobiles on the colorful Tower of the Four Winds.

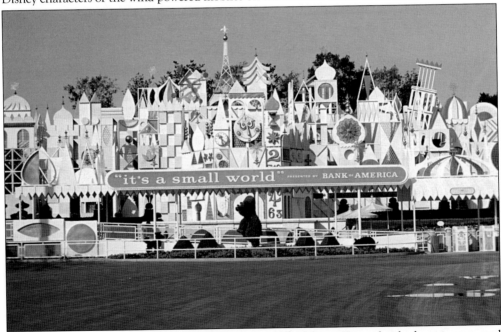

The day after the fair closed, crews began moving the show to Disneyland where it reopened with a gala ceremony on May 28, 1966. The original world's fair dolls are still performing there, and copies of the show play at other Disney theme parks. The fate of the Tower of the Four Winds remains a mystery.

The colorful luminaries were taken down after the fair and replaced with conventional streetlights. Here a group of them sits outside the former Post Office Pavilion on sawhorses waiting to be taken off site for sale. Large numbers of them could be found at salvage yards outside the fairgrounds for several years.

The luminaries were all finally sold and can be found in several locations today. This group is at the Orange County Fairgrounds in Middletown, New York, which also has several of the lights that surrounded the Astral Fountain. Luminaries can also be spotted at Canobie Lake Park in Salem, New Hampshire, the Penn Hills Resort in Analomink, Pennsylvania, the Villa Vosilla in the Catskills of New York, and until recently, at the Oklahoma State Fairgrounds.

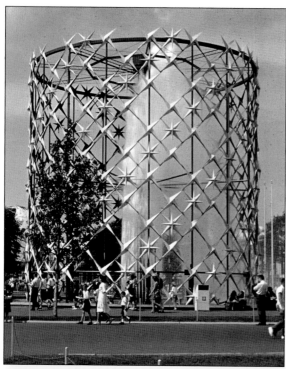

The Astral Fountain was one of seven specially designed fountains commissioned by the New York World's Fair 1964–1965 Corporation to beautify the fairgrounds. It featured a central column of water 70 feet high enhanced by a fretwork of a star-patterned design that rotated around the central column.

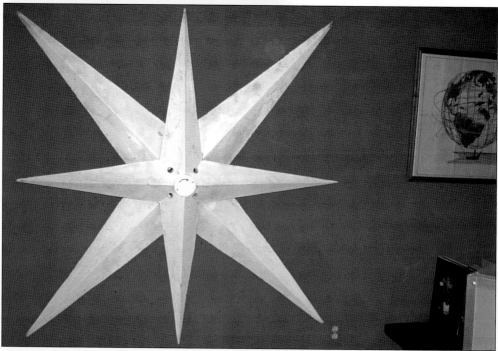

None of the fair's fabulous fountains were retained for the post-fair Flushing Meadows-Corona Park, although some of the plumbing for the Astral Fountain was left in place. Perhaps the only surviving piece of the Astral Fountain, a star from the fretwork, can be found in the collection of Gary Holmes. (Courtesy of Gary Holmes.)

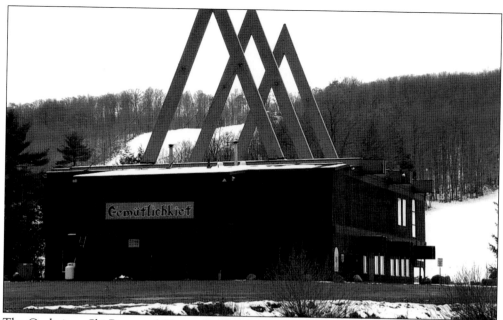

The Cockaigne Ski Resort of Cherry Creek relocated the Austria Pavilion to its property just outside of Jamestown where it became the resort's base lodge. It took two months, 14 semitrailers, and 21 railcars to dismantle and ship the structure from Flushing Meadows. The pavilion/lodge was opened in February 1966 and has been welcoming visitors to the resort ever since. (Courtesy of Larry Romer.)

Much of the Traveler's Insurance exhibit, the Triumph of Man, was moved to COSI (Center for Science and Industry) in Columbus, Ohio. It remained there until 1999 when the museum moved to a new facility. According to museum officials, the exhibit did not fit the new museum, had deteriorated over time, and was not salvageable. A few small pieces were retained for an exhibit on the history of the museum.

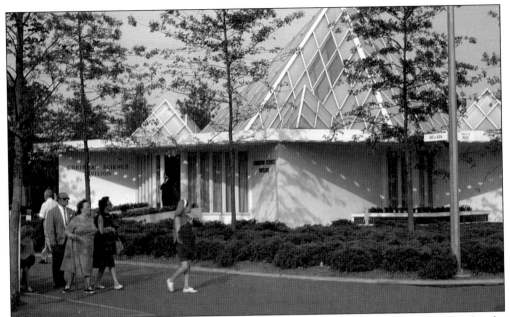

The Christian Science Pavilion, designed by Edward Durell Stone, survived after the fair for 41 years before it met its demise. Transported via the Panama Canal to Poway, California, it became a Christian Science church there. In 2005, the congregation put the pavilion up for auction for $1, aware of its historic significance. No buyer was found, and the structure was demolished in 2006 to make way for a larger sanctuary.

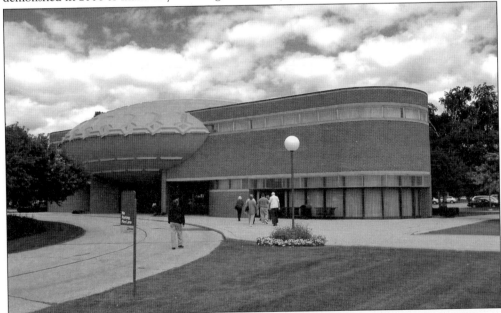

The soaring 90-foot white petals that suspended the Golden Rondelle Theater of the Johnson Wax Pavilion at the fair were discarded when the disk-shaped structure was relocated to the S. C. Johnson headquarters in Racine, Wisconsin. Today visitors may still view the pavilion's Academy Award–winning film, *To be Alive!*, as part of the Friday afternoon public tour of S. C. Johnson's historic Frank Lloyd Wright–designed administrative campus in Racine.

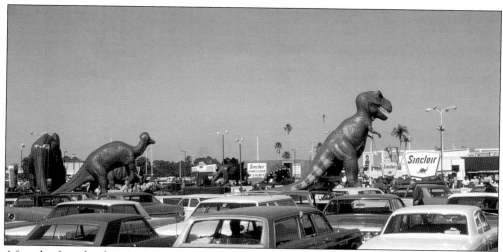

After the fair, the dinosaurs of the Sinclair Dinoland became part of a promotional three-year road show that took them to shopping centers around the United States. They were transported in a caravan of nine specially adapted 40-foot flatbed trailer trucks. After their tour, the dinosaurs were donated to various parks and museums around the country. Brontosaurus and tyrannosaurus can be found at Dinosaur Park in Glen Rose, Texas. Triceratops is at the Louisville Science Center in Louisville, Kentucky. Stegosaurus can be found at Dinosaur National Monument in Harpers Corner, Utah. Corythosaurus resides in Riverside Park in Independence, Missouri. Struthiomimus is on display at the Milwaukee County Public Museum in Milwaukee. Trachodon can be viewed at the Brookfield Zoo in Chicago. The whereabouts of the ankylosaurus and the ornitholestes are unknown.

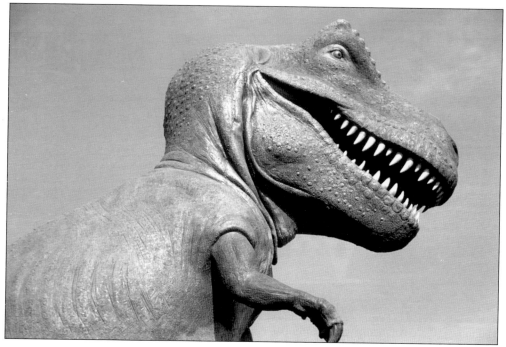

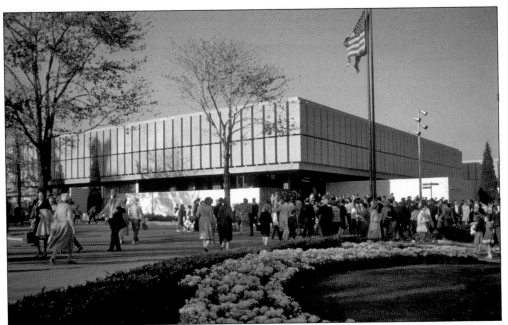

Life magazine called it "the jewel of the fair." The Spanish Pavilion was the most ambitious international pavilion of the fair, featuring priceless works of art and magnificent restaurants. Upon hearing that the building was available for sale following the fair, flamboyant St. Louis mayor Alfonso J. Cervantes set out to raise the millions of dollars it would take to bring the pavilion to St. Louis to become a convention center.

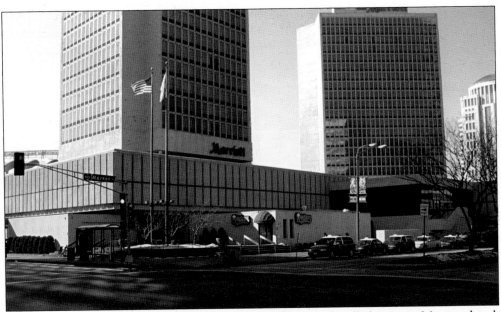

The new convention center was a failure, and the pavilion eventually became a Marriott hotel. Two multistory towers were constructed over the pavilion, which now serves as the lobby and banquet facility. In 2005, it was converted to a Hilton, with promises to restore some of the artwork covered over in earlier years. (Courtesy of John McSweeney.)

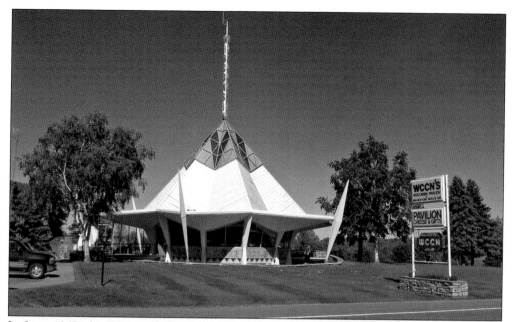

In June 1967, the Wisconsin Pavilion rotunda was reconstructed on State Highway 10 just outside of the west-central Wisconsin town of Neillsville. The Wisconsin Pavilion was eventually acquired by Central Wisconsin Broadcasting from Ivan Wilcox for $41,000. Today the Wisconsin Pavilion is home to WCCN radio in Neillsville and houses a gift shop featuring Wisconsin-made products.

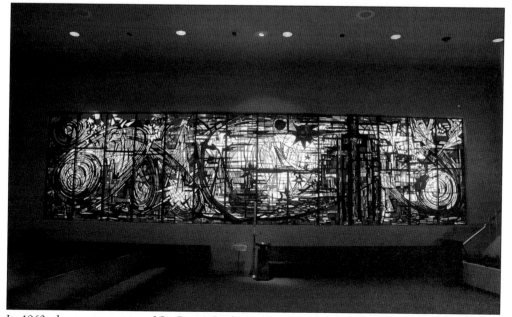

In 1963, the congregation of St. Peter's Lutheran Church in Granada Hills, California, funded the creation of a large stained-glass window that was displayed at the Protestant and Orthodox Center. After the fair, it was incorporated into their new church building, where it has survived two earthquakes. The window is now awaiting restoration to address issues caused by strong sunlight and heat over the years.

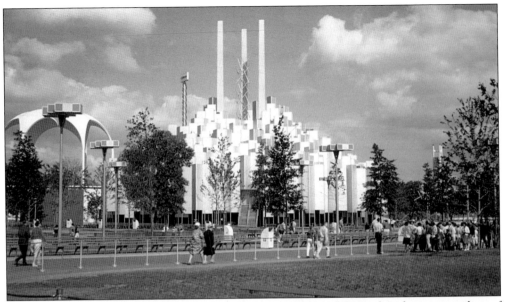

The investor-owned electric utilities presented a show called *Holiday with Light* in its pavilion of stacked prisms called the Tower of Light. The main character in the show was Benjamin Franklin, a fantasy creation resembling two large lightbulbs attached at their sockets and dressed as Franklin. Franklin extolled the wonders of total electric living to visitors to the Tower of Light.

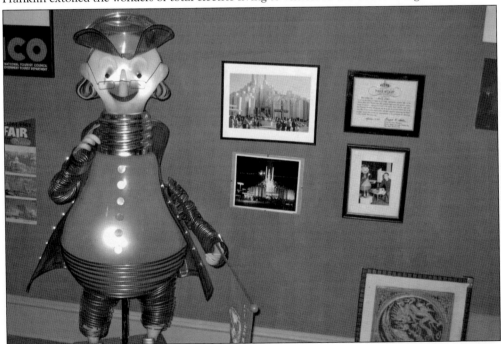

Back in Liberty, New York, 12-year-old Gary Holmes could not get enough of the world's fair, having attended it nearly a dozen times. He wrote to the managers of his favorite exhibits asking if he could have a souvenir from their pavilion's show once the fair was over. Much to his delight, the electric companies sent him Ben Franklin. Today Franklin is the centerpiece of Holmes's fabulous collection of mementoes from the fair. (Courtesy of Gary Holmes.)

More than 1,000 molded chairs circled the Chrysler Pavilion's Autofare Islands, providing welcomed relief to sore footed, fair-weary guests. The chairs were among hundreds of thousands of items put up for sale following the close of the fair, and many were snatched up by scavengers looking for inexpensive, yet very sturdy lawn chairs.

The Gary Holmes collection of world's fair memorabilia includes one of those Chrysler chairs. Seated in his chair is Carby Carburetor, star of the Bil Baird marionette-puppet cast of Chrysler's Show-Go-Round attraction. Holmes has the 1964 Carby Carburetor. All new marionettes were created for the 1965 season. Other Baird puppets from the Chrysler show can be found at the Charles H. MacNider Museum in Mason City, Iowa. (Courtesy of Gary Holmes.)

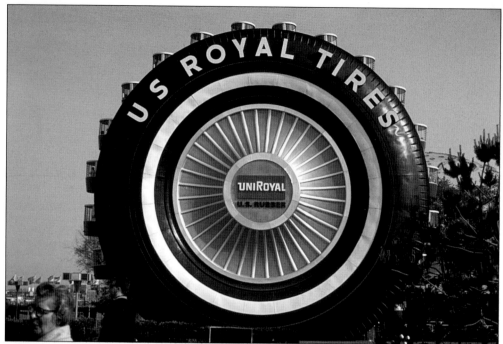

What is a fair without a Ferris wheel? U.S. Rubber sponsored the New York world's fair's version in the form of an 80-foot-tall U.S. Royal tire. Red gondola buckets rotated around the edge of the tire to give riders a spectacular view of the fairgrounds.

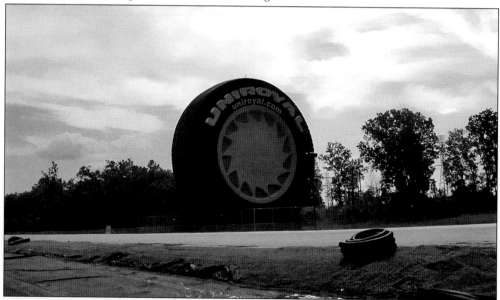

When the fair ended in 1965, the tire was shipped by rail to Detroit, were it was reassembled outside a Uniroyal sales office in Allen Park, Michigan. The Ferris wheel mechanism and gondolas inside the tire were not retained. Today the giant tire towers over Interstate 94 near Detroit's Metropolitan Airport. Uniroyal takes great pride in its world's fair legacy, taking pains to ensure that the tire is properly maintained. The tire was remodeled and renovated in 1994, 1998, and 2003. (Courtesy of Mary Ellen Coughlan.)

Belgian waffles were the food hit of the fair, so many snack bars and restaurants added the strawberry-covered treats to their menus. Most fair enthusiasts agree that the best ones were sold by the Vermersch family at their Bel-Gem Waffles stands. The family still sells waffles each year at the New York State Fair in Syracuse, keeping a bit of the fair alive today.

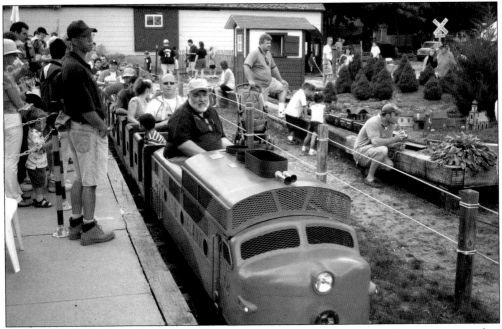

The miniature train that circled the Long Island Rail Road exhibit is still entertaining riders both young and old. It has been restored by the Railroad Museum of Long Island and circles its site in Riverhead. The museum is also restoring the diesel engine cab originally displayed at the fair. (Courtesy of the Railroad Museum of Long Island.)

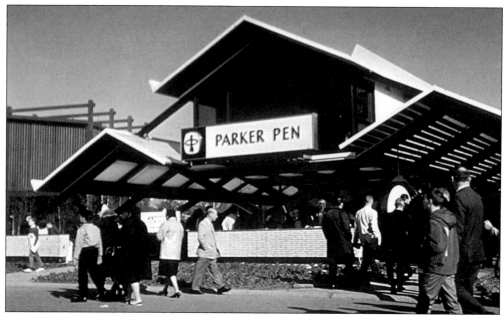

The Parker Pen Pavilion was a simple, open-air structure that invited visitors to sign up for a pen pal. It was purchased by the Lodge of the Four Seasons in Lake of the Ozarks, Missouri, and was relocated there following the fair. For many years, it served as an open-air shelter house, looking much as it did at the fair. Eventually it was enclosed and now houses the administrative offices for the lodge.

Ten tall pillars graced the entrance of the Hall of Free Enterprise. Mounted on each pillar was a plaque engraved with the economic principle on which the Ten Pillars of Economic Wisdom were based. Following the fair, the pavilion was offered to the Amway Corporation, which elected to take only the plaques. The plaques are mounted on glass-covered pedestal inclines outside the Amway World Headquarters building in Ada, Michigan.

Eight

THE END OF THE FAIR

To everything there is a season,
a time for every purpose under the sun.
A time to be born and a time to die.

—Ecclesiastes 3:1–2

It is difficult to imagine spending more than five years and $1 billion to transform a city park into a square mile of fantastic buildings, roadways, fountains, and gardens, and then, after a year and a half, demolish the whole enterprise and restore it to grass, trees, soccer fields, and tennis courts. This was the reality of the 1964–1965 New York World's Fair.

Most of the fair came down quickly. It had to. Exhibitors were given a mere 90 days to remove their displays and demolish their structures. After demolition was completed, the display areas were to be top soiled, seeded, and appropriately planted. Under the terms of the lease of Flushing Meadows Park from the city, the New York World's Fair 1964–1965 Corporation was required to complete its demolition and restoration program within four months after the exposition's closing. The fair asked for an initial extension of the city's deadline for occupancy of the park to December 31, 1966, then asked for a second extension to December 31, 1967. On October 28, 1966, they informed the commissioner of parks that the park restoration program would be completed by June 1, 1967. The formal ceremony for turning over the site to the city was held on June 3, 1967.

Why the extensions? The New York World's Fair 1964–1965 Corporation had failed to enforce the demolition security deposit requirements under the lease agreements with exhibitors. When the fair closed, a number of exhibitors simply defaulted on their obligations to demolish their pavilions and just walked away. The corporation, facing near-bankruptcy itself, pursued every means within its power to negotiate a demolition settlement with exhibitors who had failed to remove their pavilions. The corporation was eventually forced to spend over a half million dollars from its dwindling coffers to remove some 35 abandoned pavilions to satisfy the lease obligation to the city.

Here today and gone tomorrow; that is the nature of a world's fair. In the nearly half century since the fair closed, the trees and shrubs that exhibitors were required to plant in place of their pavilions have matured. The fair has truly become a park once again.

The final days of the fair were hectic, and it must have seemed like all of New York had come to say goodbye. With only one more day to go, crowds of people are trying to make their way across a very crowded Meadow Lake Bridge. (Courtesy of John Pender.)

Although fairgoers had been generally well behaved during most of the fair, the final days were marred by an amazing number of people who decided to take a part of the place home with them. It started simply enough with some people posing in the flower beds, while others started helping themselves to some of the plants. (Courtesy of John Pender.)

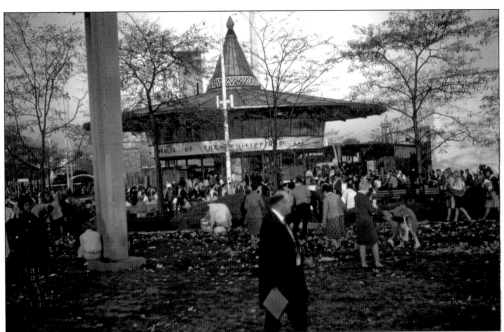

Suddenly the rush was on to take something—anything—home. Normally law-abiding housewives ripped plants out of the ground, while other guests started pulling signs off walls or tried to take display items. The hopelessly out-numbered guards could do little to stop the frenzy. Luckily no one was hurt in the melee. (Courtesy of John Pender.)

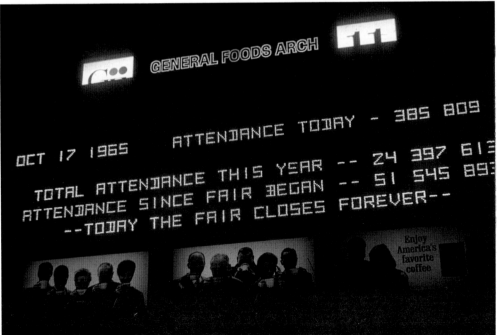

Finally it was all over. As this General Foods information arch shows, more than 51 million people had enjoyed the fair during its two seasons. Attendance had been less than projected, but the fair went out with a bang. (Courtesy of John Pender.)

Anyone returning to the fair after it closed would have been disappointed, for all of the entrances had been sealed and signs warned them to stay out. A surprising number of people did show up; some looked for souvenirs no doubt and others just wanted one last look before it was all gone.

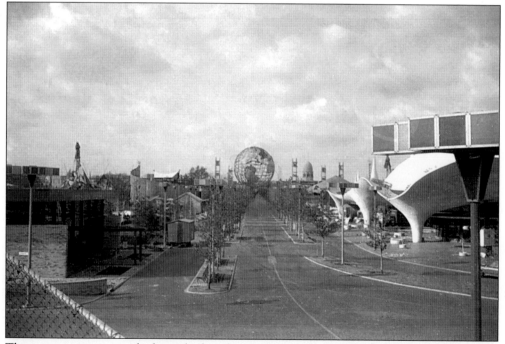

There were some ways to look inside though, mostly from the neighboring highways. This view down a deserted Avenue of Africa towards the Unisphere was taken from the shoulder of the Van Wyck Expressway.

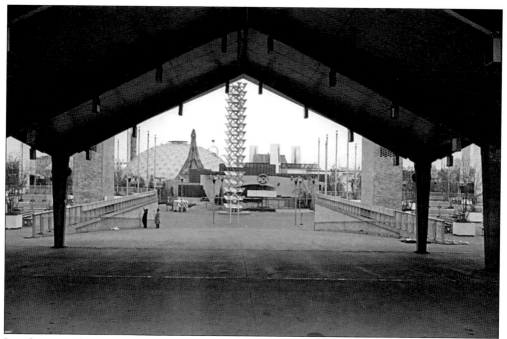

Just days ago, this ramp was full of thousands of people enjoying the end of two years of wonder. Now it is all but deserted, and work has already begun on the process of demolition.

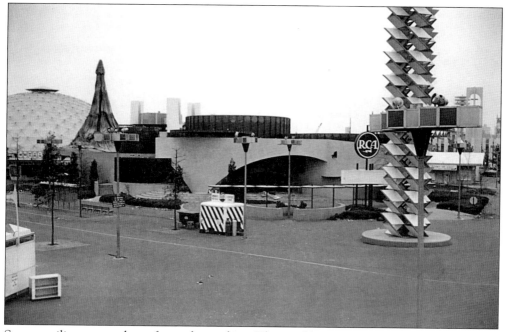

Some pavilions came down faster than others. The tentlike structure to the left of the RCA Pavilion is the deflated roof of a Brass Rail snack bar. When the power was cut off, the balloonlike roof quickly deflated.

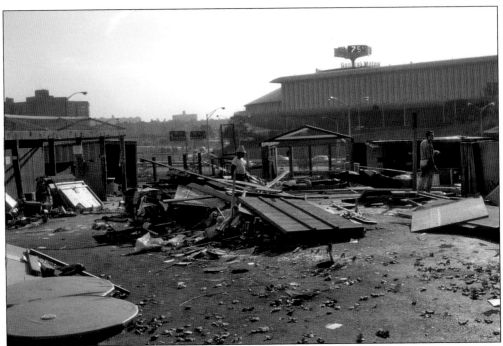

Some pavilion operators wasted little time tearing things down and heading home. Here is what is left of the Alaska Pavilion just two days after the fair closed. (Courtesy of John Pender.)

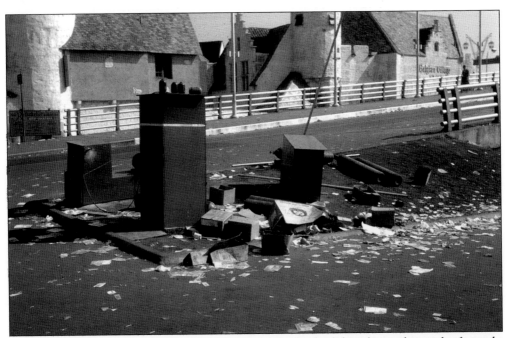

The once-attractive fairgrounds had become a mess in the final days due to the crush of crowds, and things did not get better after they left. It had been five days since the fair closed when this picture of a balloon stand was taken, and there is still trash everywhere. The fair corporation had to call in special cleanup crews due to complaints about rats. (Courtesy of John Pender.)

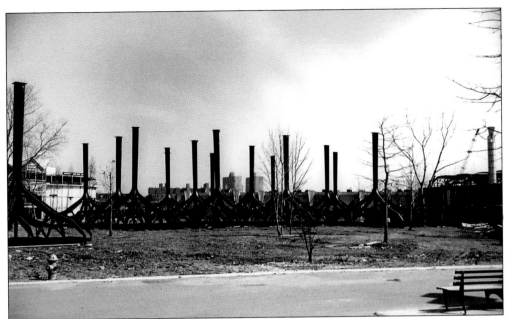

These poles reaching into the sky are the trunks of the metal "trees" that had once supported the IBM Pavilion's roof. Turned upside down, they failed to attract interest from anyone for their abstract design. Here they await purchase by a salvage company to be later cut apart as scrap metal. Recently the few surviving pieces of the IBM Pavilion have commanded high prices at auctions.

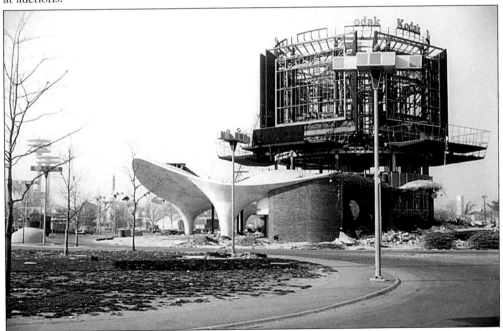

Kodak was one of the first pavilions constructed, and it was one of the first razed. Most of the moonscape roof is gone and the frames for the giant photographs will be removed soon as well. Although the structure looked like it was constructed of solid concrete, it was actually made of concrete-covered wood, so it was easily destroyed by the wrecking crews.

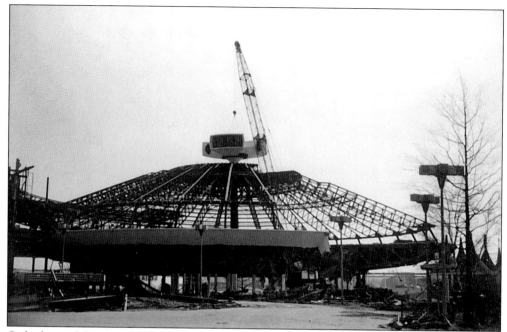

Only the steel framework is left of the once-mighty General Motors Pavilion as a crane prepares to remove the rotating display from atop the rotunda section. The pavilion was a salvager's dream come true because of the tons of structural steel that could be sold for scrap following the demolition.

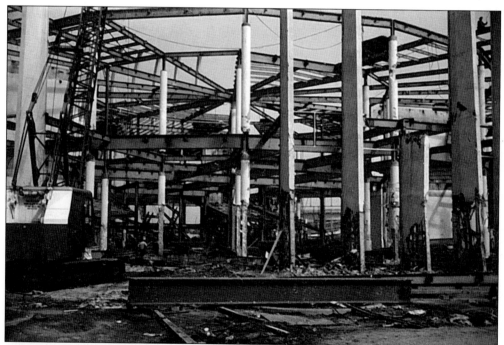

Some thought was given to retaining the Wonder Rotunda portion of the Ford Pavilion as an extension of the Hall of Science after the fair closed. But the cost of retrofitting it proved too high, and the rotunda was demolished along with the rest of the massive pavilion.

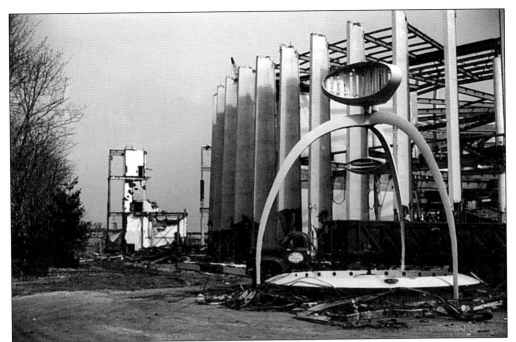

Photographs of the fair's demolition sometimes reveal strange patterns of work. While one might have thought that smaller items like this platform, once used to showcase Mustangs, might have been the first part of the Ford Pavilion to be removed, for some reason, it was left standing while the main structure was being taken apart.

Workers crawl over the battered hulk of the Hollywood USA Pavilion as they separate any recyclable metals from the ruins. A General Foods information arch remains standing in the background. The arches were one of the last items to be removed from the site before it was restored as a park, and they probably helped orient demolition workers.

The Tower of the Four Winds once stood over this display area at Disney's *It's a Small World*. The tower never made it to California with the rest of the ride, and its fate remains a mystery. There are persistent rumors that it was cut up and thrown in the nearby Flushing River during demolition.

Only the circular forms give a hint that this was once the RCA Pavilion. Soon even they were gone, leaving only an empty plot of dirt.

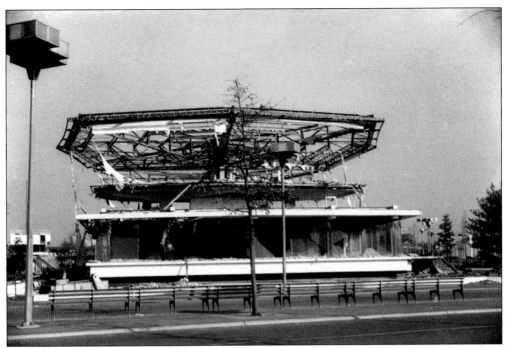

Vacant buildings always seem to attract people who like to break windows, and the Festival of Gas Pavilion was no exception. Large broken panes of glass that once fronted the restaurant area hang in their frames, awaiting the rest of the building's destruction.

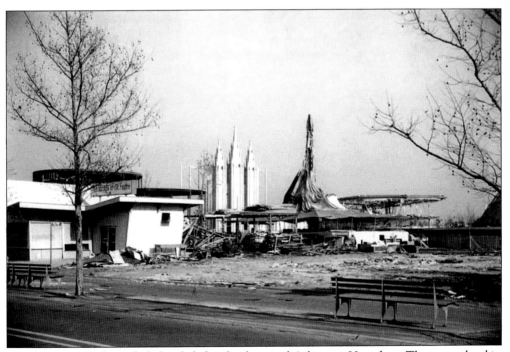

Another Brass Rail stands forlornly behind a shuttered Arlington Hats shop. The empty land in the foreground was once the home of the Protestant and Orthodox Center.

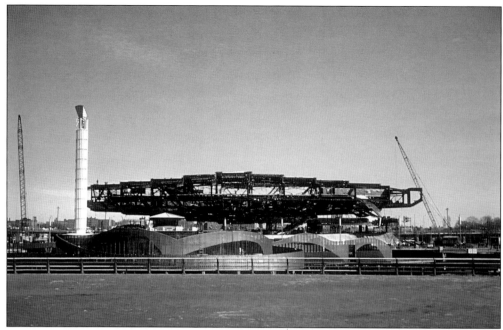

The New York World's Fair 1964–1965 Corporation considered retaining the extensive underground portion of the Bell System Pavilion, but no workable use was found for it. Even if it had, the main part of the building would have had to come down. By March 1966, the fiberglass outer cover was gone, and workers were dismantling the huge steel frame.

It became harder and harder for the demolition crews to find their way around the site as the distinctively shaped buildings were reduced to piles of bent metal and broken concrete. Signs for several pavilions were left as guideposts, such as this one for the Formica Pavilion, which stands on a desolate Avenue of Automation.

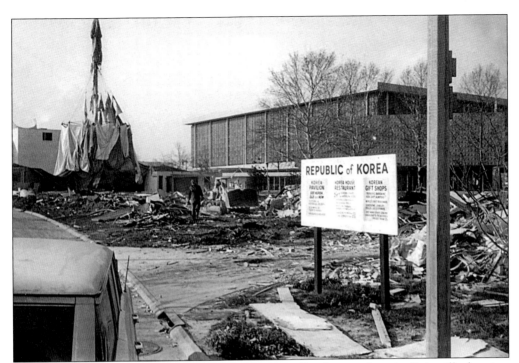

This sign was left in place to mark the site of the Korea Pavilion, and ironically it still advertises the bargains to be found in the gift shop. There probably was not much left in stock, but then again, the advertised restaurant was not doing much business either.

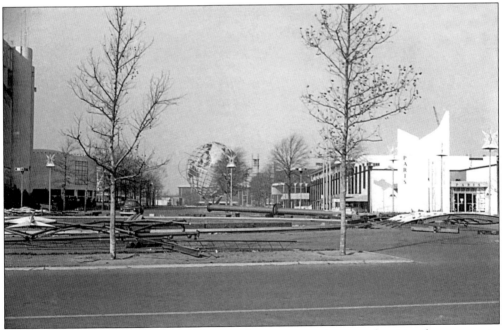

Pieces of the once-impressive Astral Fountain lay strewn on the ground waiting for someone to cart them off. The main water jets were left in place for use in the post-fair park and are still there today, but the fountain has not worked for years.

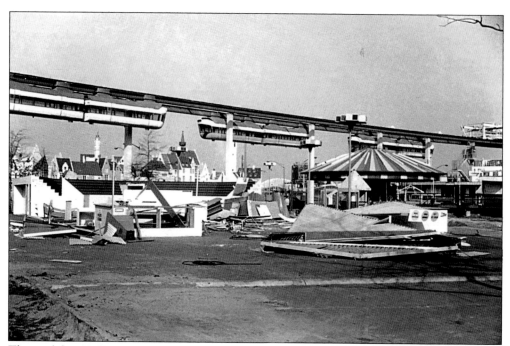

Three of the AMF Monorails await their fate above the ruins of Carousel Park. Plans to reuse them at an airport fell through, and several of the cars were last seen rusting away near Houston, Texas. The carousel is still in operation in Flushing Meadows-Corona Park.

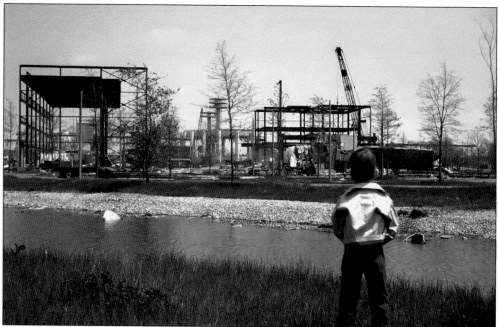

One can only wonder what this young boy was thinking as he watched the once-beautiful fair being reduced to rubble. By the time this picture of the remnants of the Hawaiian pavilion was taken in early 1966, many of the buildings had already been razed, leaving only a mixture of strange shapes and piles of debris behind.

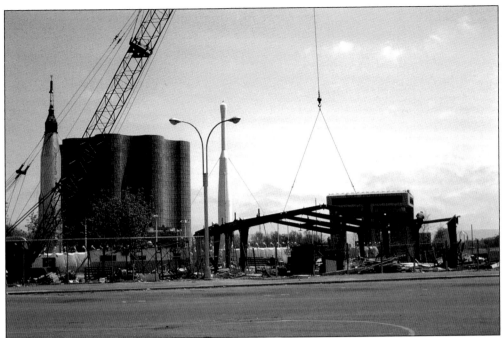

A crane begins lifting the steel rafters off the remains of the Century Grill restaurant. The nearby Hall of Science and Space Park were closed for safety reasons during the demolition work.

The Travel and Transportation Pavilion was one of the last buildings demolished. The New York World's Fair 1964–1965 Corporation had spent considerable time and effort, without success, to get the bankrupt owners to tear it down. The edge of the Greyhound Pavilion can be seen on the far right of the photograph. That building was retained with unrealized plans to convert it into a firehouse. By 1967, it too was demolished.

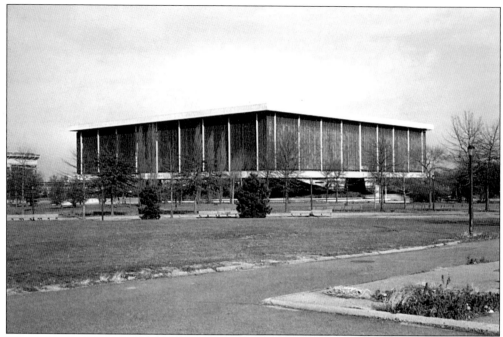

When the demolition effort was complete, the federal pavilion still stood above the playing fields of the new park. When turned over to the city, the building was in perfect working order. However, that was not the case for long.

With only a simple chain link fence to protect it, the pavilion attracted a steady stream of unauthorized visitors, and vandalism soon began to take its toll on the structure. Everything of value was stripped from the building, making it increasingly less likely that any use would be found for it.

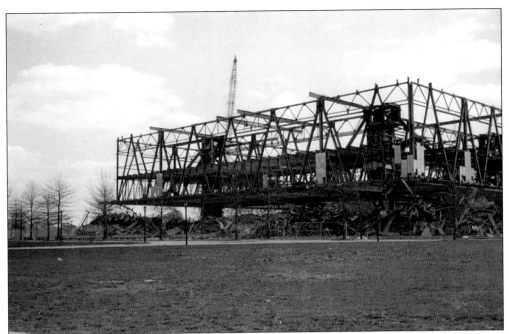

By the early spring of 1977, the building's decay had passed the point of no return, and it was finally demolished. The steel framework of the pavilion was revealed when the colorful plastic wall panels were removed. By that time, there was not much left of the interior to tear out, because it had been so ravaged by vandalism.

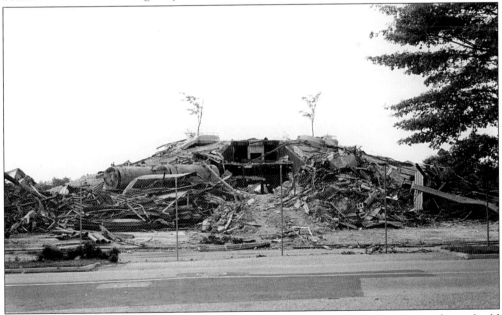

The once-majestic United States Pavilion was reduced to a jumbled pile of twisted metal, old boilers, and associated debris. Because the federal government had built the pavilion to be permanent, 2,300 piles were driven to support the massive structure. The huge Arthur Ashe tennis stadium, constructed on this same site in 1997, makes use of those support piles. That is the only legacy that remains of a multimillion dollar gift.

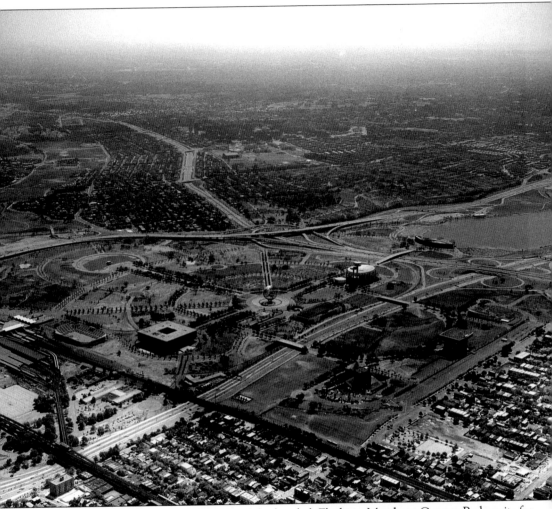

Seen just after the major demolition work had ended, Flushing Meadows-Corona Park waits for the return of crowds to its still and empty streets. Soon after new sports fields and picnic areas were added, and the park came alive again. Although the funds were not there to create the grand park dreamed of by Robert Moses, the fair helped improve the site in many ways. The Hall of Science was built as a permanent addition to the park, and a new zoo was soon added as well. The Amphitheater, New York State Pavilion, and United States Pavilion were also there but without any real plans to utilize them.

Nine

THE FAIR'S
GREAT LEGACY

*We believe it is no exaggeration to say that two World's Fairs
have produced . . . one of the very great municipal parks of our country.*

—Robert Moses, July 23, 1965

Robert Moses had one overriding goal as he presided over the 1964–1965 New York World's Fair: it would allow him to complete the great park that had been planned but left unfinished by the bankrupt 1939–1940 fair. Millions of dollars of improvements were poured into the site with the future park in mind. New roads, new utilities, and new landscaping were installed, and major works of art, pools, and fountains were created to beautify what was to become Flushing Meadows-Corona Park.

Although the fair's projected $50 million surplus was never realized, Moses elected to put the remaining $1.5 million in cash assets into the park rather than to repay the fair's debts, much to the dislike of its creditors. This money was used to rebuild the site as a park with athletic fields and other facilities but not on the scale originally envisioned.

The exposition had produced many exceptional structures, and there were suggestions that a number of them be retained. Moses and his engineering team insisted that buildings without a useful purpose did not belong in the post-fair park. Therefore, most of the fair was demolished within 6 to 12 months following its close, and only a handful of structures were left behind. These few survivors included the fair's administration building, the press building, post office, maintenance building, the Singer Bowl stadium, and the geodesic steel framework of the Pavilion—all structures built with New York World's Fair 1964–1965 Corporation funds. Of the nearly 160 other pavilions, only the Space Park, Heliport, Greyhound, United States, and New York State Pavilions were saved. The New York City Building and the Amphitheater, both constructed for the 1939–1940 fair, were also spared the wrecking ball, as was the Hall of Science, which was always planned as a permanent museum.

A number of these structures have also been demolished since the park reopened in 1967. Today most of the former fair site is open land, crowded only with visitors enjoying Moses's park. Looking beyond the athletic fields, though, a visitor can often make out landmarks that show where the magic of the fair once stood.

Many of the fair visitors arrived by subway, and new platforms were added to provide easy access to both the fair and the new Shea Stadium. Crowds of people emerged from the station each day ready to take in the sights, sounds, and tastes of the fair.

The area is much quieter today and is only crowded for New York Mets games, the U.S. Open, or other special events. The cranes in the background are building Shea Stadium's replacement, as another fair legacy is lost.

Excitement mounted as visitors approached the entrance and the first pavilions came into sight. Brightly colored flags and welcoming announcements helped set the mood along the wooden walkway.

At first glance, one might think the fair was somehow still there today, for the entrance canopy that once sheltered the turnstiles is still there. The flags are gone, though, along with the people.

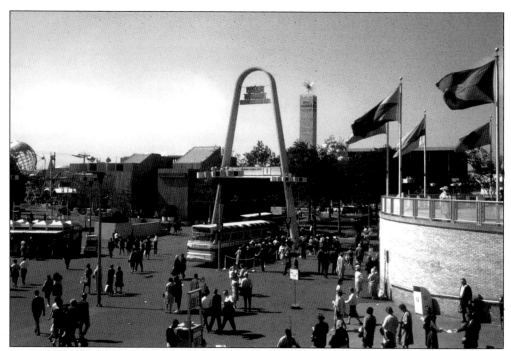

Once inside the gates, visitors entered Gotham Plaza, where several avenues led off to the different areas of the fair. Here a Greyhound bus passes under one of the General Foods information arches. To the left is the Avenue of the Americas, which led to the Unisphere.

Today a mosaic tribute to the Trylon and Perisphere is at the center of Gotham Plaza, and smaller mosaics salute exhibits from both fairs. The trees have grown in the passing years, providing a welcome green oasis just as Robert Moses had long envisioned.

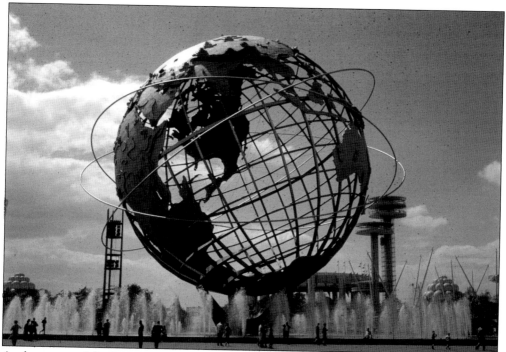

At the center of the fair stood the Unisphere, which was every bit as impressive as its designers had hoped it would be. Pulsating jets of water enhanced the experience, and many fairgoers cooled their aching feet in the surrounding pool.

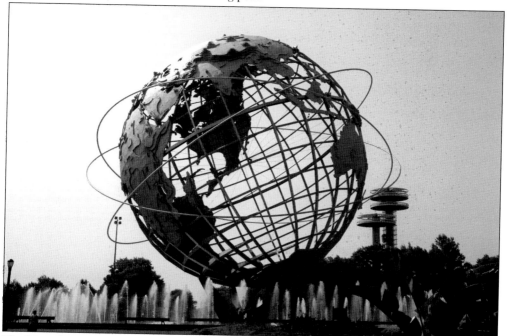

The Unisphere is still there, of course, but the fountains are only run during the U.S. Open and other special events. All of the fountains in the park are generally left empty due to liability concerns, for visitors often used them as makeshift swimming pools.

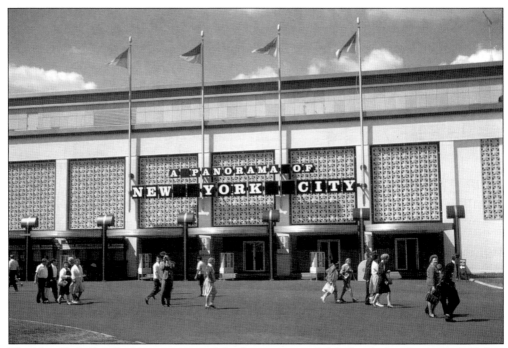

The New York City Building was one of the few structures left behind after the 1939–1940 fair, and it served well during the second fair. New Yorkers loved trying to spot their houses or their streets on the giant panorama model of the city.

Today the building is home to the Queens Museum of Art, which maintains a small display about the two fairs that once graced the park. The panorama is still there and has recently been updated to reflect changes in the city since the fair. The building looked better during the fair days, but there are plans to expand the museum that may result in a new facade.

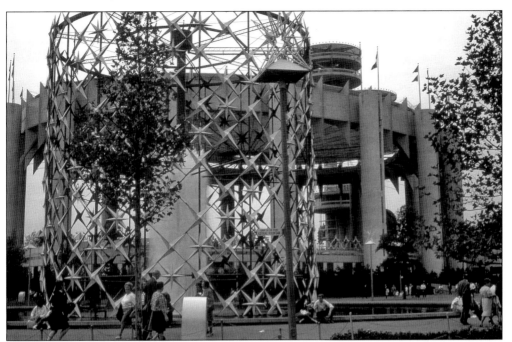

When the rest of the fair was demolished, the New York State Pavilion was turned over to the city in perfect working order. The towering fretwork of the Astral Fountain was removed, but the pumps and water jets were left in place to be enjoyed as part of the new park.

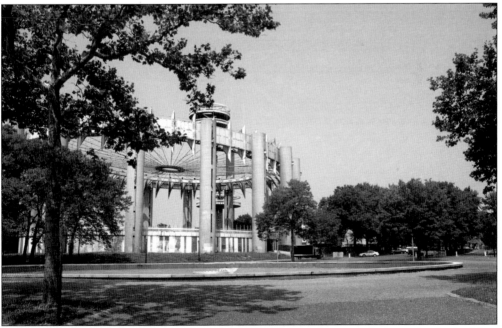

Today the New York State Pavilion is a decaying hulk. Despite several proposals, the building was only used briefly as a skating rink and is unsafe to enter today. Hopefully a way will be found to save it before it suffers the fate of the federal pavilion. The base of the Astral Fountain is still there, but it has not worked in years, and vandals have sawn off some of its nozzles.

The longest lasting legacy of the two fairs is likely to be the set of time capsules buried for 5,000 years, assuming someone will still be here to find them and dig them up. Scientists worked for several years to develop what they hoped would be long-lasting containers for the collections of artifacts and historical records.

The time capsules are now the center of a pleasant circle of benches and a shady grove of trees. Hopefully future archeologists will remember that the stone marker only covers the site of the 1939 capsule and that the 1964 one is buried several feet off to the right.

In 1964, the AMF Monorail station was easy to find, for it was one of the tallest structures in the Lake Amusement Area. Guests entering at the Meadow Lake gate were greeted with this view, which could only have served to make them more excited about the wonders awaiting them at the fair.

Today there is little to show that the monorail was ever here. All of the buildings were removed from this section of the fairgrounds, but the exact site can be found by matching the median, light fixtures, and trees. Many of the footings for the support pylons can also be found because the surrounding ground has settled, making it possible to walk the route of the track once again.

Robert Moses had planned to leave a greatly improved park behind, with collections of art and statues, but the financial failure of the fair changed all that. He did succeed in part, however, as *The Rocket Thrower* and several other statues from the fair are still there to provide a touch of class among the sports fields that dominate the landscape.

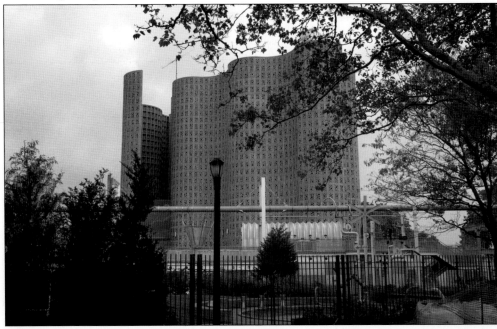

Another enduring legacy is the Hall of Science. While several additions have partially blocked the classic lines of the Great Hall, the museum is still a hit with local students and is usually crowded with young guests enjoying the displays. Two vintage rockets were recently restored, remnants of the once-impressive U.S. Space Park.

No area in the park has changed more than the former Chrysler Pavilion site. Home to the Queens Zoo, the once-flat grounds have been contoured to provide more natural settings for the animals in what was hailed as the city's first cageless zoo.

While many of the people who enjoy the park are too young to have been at the fair, Moses's urban oasis is a welcome addition to Queens. The pavilions may be gone but the fair lives on, at least in the memories of those who were there.

www.arcadiapublishing.com

Discover books about the town where you grew up, the cities where your friends and families live, the town where your parents met, or even that retirement spot you've been dreaming about. Our Web site provides history lovers with exclusive deals, advanced notification about new titles, e-mail alerts of author events, and much more.

MADE IN THE

Arcadia Publishing, the leading local history publisher in the United States, is committed to making history accessible and meaningful through publishing books that celebrate and preserve the heritage of America's people and places. Consistent with our mission to preserve history on a local level, this book was printed in South Carolina on American-made paper and manufactured entirely in the United States.

This book carries the accredited Forest Stewardship Council (FSC) label and is printed on 100 percent FSC-certified paper. Products carrying the FSC label are independently certified to assure consumers that they come from forests that are managed to meet the social, economic, and ecological needs of present and future generations.

FSC
Mixed Sources
Product group from well-managed forests and other controlled sources

Cert no. SW-COC-001530
www.fsc.org
© 1996 Forest Stewardship Council

Find *Your* Place in History.